Praise for CODE | WORDS

Some of the most exciting, important and wide-ranging thinking about museums and their global role that has happened this century.
Sree Sreenivasan, Chief Digital Officer, Metropolitan Museum of Art

Daring, intelligent and provocative, an absolute must for all forward-thinking museums.
Jane Finnis, Chief Executive, Culture24

Anchored in case studies around the world, linking strategy, technology, and psychology. Like the future, it is experimental, uncertain, and brilliant.
Nina Simon, Executive Director, Santa Cruz Museum of Art and History, author of The Participatory Museum

Brings together exciting new ideas and challenging thought leadership from some of the most interesting museum innovators of our time.
Jim Richardson, Founder, MuseumNext

An engaging and timely exploration of contemporary issues that face museums around the globe; how to engage with digital technologies and the changes they make possible.
Laurent Gaveau, Director, The Lab, Google Cultural Institute

At last a book which brings together technological and social innovation in museums.
Tony Butler, Executive Director, Derby Museums Trust

A refreshing new approach to the interface of technologies, museums and especially younger museum professionals.
John Reeve, Institute of Education, University of London

CODE | WORDS

CODE | WORDS

Technology and Theory in the Museum

Edited by

Ed Rodley, Robert Stein & Suse Cairns

MUSEUMSETC | EDINBURGH & BOSTON

CONTENTS

Foreword 10
Seb Chan

ONE CODE | WORDS: The Back Story 14
Robert Stein

TWO Dark Matter 22
Michael Peter Edson

THREE Museums… So What? 48
Robert Stein

FOUR Love You, Love You Not 82
Luis Marcelo Mendes

FIVE Towards the Sociocratic Museum:
How and Why Museums Could Radically
Change and How Digital Can Help 92
Bridget McKenzie

SIX Museums and #BlackLivesMatter 108
Aleia Brown and Adrianne Russell

SEVEN Change 122
Nick Poole

EIGHT Changing Museums in a Perpetual Beta World 134
Janet Carding

NINE A Place for Everything: Museum Collections,
Technology and the Power of Place 164
John Russick

TEN Wanna Play? Bridging Open Museum Content
and Digital Learning in Schools 178
Merete Sanderhoff

ELEVEN Embracing a Digital Mindset in Museums 206
Mike Murawski

TWELVE The Virtues of Promiscuity
Or Why Giving it Away is the Future 224
Ed Rodley

About the Authors 252

Also from MuseumsEtc 260
Colophon 264

FOREWORD

Seb Chan
Chief Experience Officer
Australian Centre for the Moving Image

CODE | WORDS ARRIVES at an important juncture for museums. The world has been transformed by the growth and expansion of the internet and the increasing digitisation of culture and industry. The web, itself, is now in its third wave having passed from a novel information-led experience through "social" and now into a largely mobile experience. This shift to mobile has brought with it many first-time users in the developing world, as well as relegated the idea of logging-on to the distant past – we are now always connected. Internet access, increasingly, is now both considered and provided as a utility.

Museums, though, have been tardy in their adoption of digital services – despite museum workers' predictions as early as the 1960s of the coming of digitisation, centralised databases, and the potential of truly globalized access. Our cousins, the libraries, have been the canary in the mine since the 1990s and yet continue to struggle with their own transformation from book-bound knowledge to knowledge-as-a-service, made all the more complex by the shifting sands of subscription journals and born-digital works. UK academic Ross Parry (2013), examining organizational structures and practices, has identified the seeds of what he terms "post-digital" taking root amongst the UK's national museums, although when placed in the context of austerity cuts the long-term impact of these changes is still very uncertain.

As a series of essays emerging from a range of active practitioners, each at varying stages of their careers, produced "on the network" and originally through Medium, a post-blogging writing platform, CODE | WORDS provides a series of important vignettes of this moment of in-progress change.

Michael Edson's clarion call was the first to be published in the series and harks back to the optimism of the first and second waves of the web. And while the shift towards internet-as-utility has brought much of the "technological magical thinking" of the past two decades crashing down to earth, Edson's vision is paradoxically much easier to make a reality now than ever before. Although, as Nick Poole cautions, museums should be careful not to lose their way in their pursuit of Edson's vision of scale – there is no inherent "ethics of the web". Rob Stein, Deputy Director of the Dallas Museum of Art, forcefully argues the need for museums to shift their value proposition to their communities and warns that we lack many of the analytic skills we need as we rush headlong into quantifying our missions at the behest of boards and management teams. Merete Sanderhoff and Ed Rodley both demonstrate the value of opening up the treasure houses and make an important call for openness. Bridget McKenzie and Adrianne Russell's essays both question museums' engagement with social change, social justice and sustainability – a call echoed in Nick Poole's riposte to Edson's opener, while Janet Carding reflects on the challenges of organizational change, having led such efforts at the Royal Ontario Museum.

If there is any thread through these essays, it is the notion that museums now exist in a chaotic environment of constant change. There is no sense that "digital transformation" is a transition from one static state to another, but that the real challenge lies in building more nimble, flexible, responsive and ultimately resilient institutions. What this means, as many of the contributors suggest, is that digital transformation is ultimately the transformation of the museum itself.

CODE | WORDS:
THE BACK STORY

Robert Stein

IN EARLY 2014, Suse Cairns, Ed Rodley, and I began a conversation about whether it was possible to document the kinds of conversations that each of us saw happening across the museum technology community. We each noted that the quality of debate and discourse in the field had matured substantially over the last decade, but was not yet being captured in a form which could sustain or preserve an evolving theory of digital practice in museums.

In conversations online and at conferences, many of us in the museum technology field regularly tackle challenging questions about the identity of museums, their roles in society, their responsibilities to serve a global public, and the nature of collecting, preservation, education, scholarship, primary research, and ethics in a digital age. While the influence of these ideas is widespread among the immediate community of practitioners, they are not always shared more broadly throughout the field, limiting their utility. In spite of this, those discussions are beginning to inspire change in many museums and are demonstrating the important relationship between emerging digital practices and museum theory.

We wondered how we might capture the emerging ideas that exist at the intersection of digital practice and museums in a way that would not sacrifice the discursive richness that is so integral to this community's practice. While each of us had participated in various online and print publishing efforts in the past, those had always veered either solidly towards an informal online social discussion, or towards a formal, but static and selective document. We recognized the inherently closed nature of the traditional authorship model and wondered what might be possible if a group of colleagues tackled a set of interrelated

issues at the same time, in public, with an eye towards a more formal publication as the final product? The process itself would be an interesting experiment, and the outcome – meaningful discourse and new knowledge – could be a real benefit to the field. This idea evolved into Project CODE | WORDS.

Project CODE | WORDS became an experimental discursive publishing project which gathered a diverse group of leading thinkers and practitioners to explore emerging issues about the nature of museums in light of the dramatic and ongoing impact of digital technologies on society. In establishing the CODE | WORDS project, we sought to explore news ways to spread these ideas, and to engage the global community of museum professionals to explore how we respond to the challenges and opportunities which digital technologies present.

Starting points

As a group, we felt it was important to provide some guidance to what might otherwise be a very wide-ranging set of topics. We proposed the following prompts to our authors who – to their credit – addressed these ideas and expanded our notion of what the project might become. The questions we proposed were as follows:

- Making the value statement for museums in a digital age: How can museums determine what's important and not just what's easy?
- The politics of new technologies: How do we balance the shifting equations of power, audience, and authority?
- Dialogue and discourse in museums: Who's talking and who's listening?

- Creativity, innovation, and technology: Is there a relationship between the three that's unique to museums?
- Digital curation: What does it mean to collect and preserve digital media, art, and information?
- Eschewing both technofetishism and technophobia: New digital technologies won't solve all the problems in the world, or museum, nor will they destroy everything we hold dear. Things will change, as they always do. How will we respond to those changes in a deliberate manner?

Bringing the plan to fruition

To bring these ideas to life, the team proposed the CODE | WORDS project in three phases. The first was a series of online discussions held via web chats with project team members to discuss the framing ideas of the project and test our initial assumptions about whether this idea could fly at all.

In the next phase, the team chose to use the Medium website for publishing long-form essays which attempted to tackle some of the framing ideas described above. We chose Medium because of its ease of authoring, enjoyable reading experience for long-form content, and because it offered some unique features for inline commenting at the paragraph level.

We invited the public to discuss the essays across a variety of online channels, using the hashtag #CODEWORDS, with the aim of expanding and refining the arguments presented by the authors. We also invited and encouraged the broader community to comment, critique, and submit their own essays to the growing collection of CODE | WORDS material. We're proud to say that many people took us up on that offer and several significant essays were contributed to the collection which were

generated entirely from the community.

In the final phase of the project, we had hoped from the start that the quality of work from our authors would be valuable enough to justify a more permanent print publication. Using the open discourse of the online publication, our plan was to use that feedback to further refine and hone each essay.

As you can see from this volume, the CODE | WORDS authors have contributed a set of compelling and important thoughts and ideas to this discussion. We could not be more grateful to MuseumsEtc for their support and enthusiasm for the project. Without their expertise as publishers, this print edition would not be possible. Furthermore, I think it's so important to note that MuseumsEtc has agreed to publish this work under a Creative Commons BY-NC-SA license which has allowed it to be used freely for non-commercial use in other languages and will permit aspects of the essays to be remixed and extended as these ideas continue to grow and evolve.

The story doesn't end here

We've always thought of CODE | WORDS as the beginning of an experiment in publishing. I think it's fair to say that each of the authors has hopes and dreams held in our hearts about what CODE | WORDS might become, many of which were not realized in this first attempt. Many of us feel that our goal of a highly discursive and evolving conversation on museum theory was hampered by the tools we chose and the unfamiliarity this mode of discourse has for our audiences. That being said, there are seeds of promise here for a participatory form of long-form writing that are truly exciting.

From the beginning, the project has embraced an inclusive

ethos; an intention to draw out voices from our community that need to be heard. We hope that the dialogue will not end with this publication, but rather, that diverse participants from across the museum sector will also choose to engage in this discourse, writing essays of their own, or developing the dialogue further in other ways. We hope that in reading this book, you will feel free to pick up the CODE | WORDS moniker and use it to mark your own contributions to this discussion.

The project CODE | WORDS team

In closing, we would like to acknowledge and give thanks to those early contributors whose ideas and input were so critical to creating the CODE | WORDS project and format. Some authored essays, some contributed comments and questions inline to spark discussions, and some helped us to hone our thinking about the project itself. All were instrumental in creating a meaningful discussion about the state of theory about technology in the museum field for which we are proud and thankful.

Suse Cairns	@shineslike
Ed Rodley	@erodley
Rob Stein	@rjstein
Aleia Brown	@aleiabrown
Seb Chan	@sebchan
Susan Chun	@schun
Michael Edson	@mpedson
Courtney Johnston	@auchmill
Sarah Kenderdine	
Luis Marcelo Mendes	@lumamendes

Mike Murawski	@murawski27
Nick Poole	@nickpoole1
Adrianne Russell	@adriannerussell
John Russick	
Jim Salmons	@jim_salmons
Merete Sanderhoff	@msanderhoff
Koven Smith	@5easypieces
Thomas Soderqvist	@museionist
Beck Tench	@10ch
Marthe de Vette	
Bruce Wyman	@bwyman

CHAPTER TWO

DARK MATTER

Michael Peter Edson

UNTIL THE 1960s we thought we had a pretty good idea of what the universe was made of.[1] You, me, the earth, the planets, the Milky Way, Renoir's *The Boating Party*, the pearly plastic of Elvis's guitar pick, the Great Pyramid of Giza, a finch's beak, the sound of Maria Callas' voice and everything else in the cosmos was believed to be made up of particles and energy that we could see, touch, smell, hear, or directly measure with the instruments of science.

But we were wrong. Not just a little wrong; wrong at a stupendous, almost unimaginable scale. And the way in which we were wrong tells us a lot about the way our memory institutions are using technology to accomplish their missions, and the beauty and power that exists now, just beyond their reach.

In 1967, American astronomer Vera Rubin, fresh out of graduate school and eager to begin her new career, started working on a comprehensive survey of the rotational characteristics of spiral galaxies.[2] It was to be a long, grueling project: "A program no one would care about" as she herself described it – thousands of days and nights working in anonymity, gathering data to calculate the speed at which spiral galaxies spin around their dense central cores.

But on Vera Rubin's first night of observations she noticed something startling. Spiral galaxies are beautiful, enormous structures with flat, disk-like bodies that sometimes span millions of billions of kilometers and contain hundreds of billions or trillions of stars. But as marvelous as they are, they are supposed to obey the laws gravity like everything else in the cosmos; it was an article of faith that spiral galaxies would

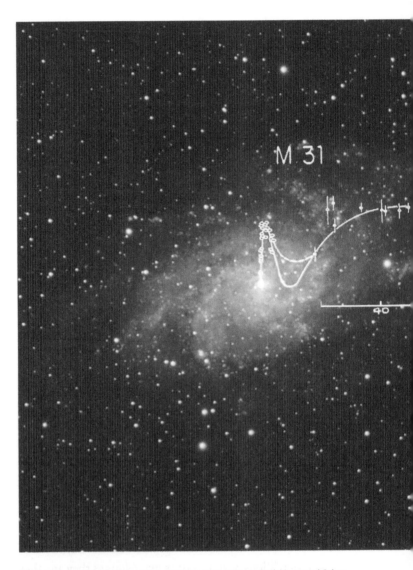

FIG. 1: Mashup of Vera Rubin's rotation curve for galaxy M-31, via "Dark Matter and Galaxy Formation" by Joel R. Primack, http://arxiv.org/pdf/0909.2021.pdf, and M31, M32, M110 (#3) by s58y, CC-BY https://flic.kr/p/7jhpzY. Image: Michael Edson, 2015 [CC-BY].

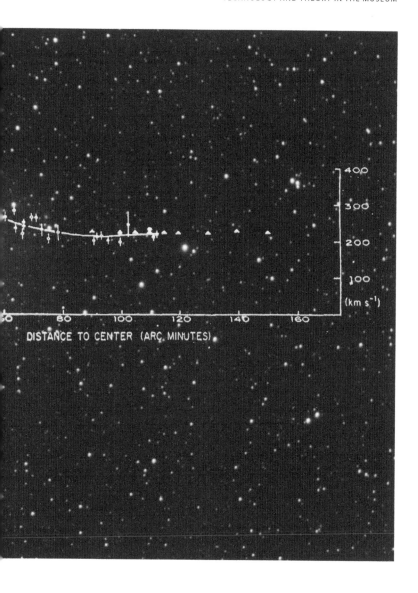

revolve around their axes just as the planets in our solar system revolve around the sun, with planets closer to the center of the system spinning faster than those that are far away.

But that is not what Vera Rubin found. She discovered on that night, and in every measurement that she or any other astronomer has taken since, that the outer regions of every spiral galaxy in the universe spun just as fast as their corresponding inner regions, regardless of whether the areas being measured were near the galactic axis or a hundred million billion kilometers away.

It could not be so. These galaxies were spinning so fast that Newton's laws of gravity dictated that they should have flown apart. In one galaxy, Triangulum, the outer regions were moving so quickly that it was as if there were 39 billion invisible suns – seven times the observable mass of the galaxy – quietly pulling the long, graceful arms of the system forward.

Where was the missing mass? Where was the energy and the gravity coming from? How do you explain 39 billion missing suns?[3]

The universe doesn't show its cards very often – flaunting a physical reality that so clearly contradicts the laws of nature – but there was the evidence in the hands of a junior astronomer on her first night of her first project of her first job. And there were only two explanations for what she saw: either there was something wrong with the laws of gravity, or there was an enormous quantity of invisible matter in the universe.

Vera Rubin had discovered dark matter. Her measurements have now been repeated on over a thousand galaxies and the results are all the same: dark matter – whatever it is – seems to comprise most of the mass of the universe:

"We became astronomers thinking we were studying the universe," Rubin said, "and now we learn that we are just studying the 5 or 10 percent that is luminous."

My colleagues and I work in amazing institutions. Some of the institutions are giants, with epic missions like *The increase and diffusion of knowledge* (Smithsonian Institution, USA), *A center for learning, dialogue, tolerance, and understanding* (Bibliotheca Alexandrina, Egypt), and *[To support] citizens in the defense of their rights and encourage the production of scientific and cultural knowledge* (Arquivo Nacional, Brasil). Some of them are small, with just a handful of staff and quiet, humble missions that are nonetheless deeply important to the people they serve.

I am talking about museums, libraries, and archives – heritage, culture, knowledge, and memory institutions – and there is really nothing like them on the face of the earth. And whether we've realized it or not, my colleagues and I who work with technology in these institutions have been participating in an extraordinary project – the building of a planetary scale knowledge sharing network for the benefit of everyone in the world.

For over twenty years we've followed every step in the explosive growth of technology and its impact on society. We've digitized our collections and put them online. We've built websites and mobile apps; livestreamed lectures and performances; and published electronic books, games, and educational materials. We've blogged, tweeted, cataloged, pinned, friended, poked, liked, crowdsourced, uploaded, downloaded, licensed, sold and organized. We've learned HTML, CSS, Java, JavaScript,

Ruby, PERL, PHP, Python, Drupal, ColdFusion, ASP, Action-Script, Applescript, C, C+, C++, C-sharp, Objective C, LAMP, RAMP, MAMP and a few dozen other technologies, and we've built things so elegant and stable that they're works of art in their own right – and so obtuse and convoluted that they'll be bringing our colleagues to tears of frustration for years to come.

We've reached, and to varying degrees satisfied, hundreds of millions of people with our efforts, and for more than twenty years we have done it all on shoestring budgets (when we were lucky enough to have budgets at all), in direct competition with some of the biggest and most aggressive media companies in the world, through three global recessions, a global banking crisis, wars in Afghanistan, Iraq and "terror" (not to mention 61 other global conflicts), and at the end of the day we've almost always generated a positive impact on the visitation, reputation, and financial sustainability of our hallowed institutions.

That's not a bad stretch of work for what is mostly a bunch of self-taught hackers and designers who've been making it up as we've been going along.

But as I look back on these accomplishments and I think of where we are today; how our institutions think about the World Wide Web 25 years after its birth, and the degree to which we understand and are taking advantage of its full capacity to serve, educate, enlighten, and empower our constituents, whoever they are and wherever they live, my thoughts return to the story of Vera Rubin and dark matter.

Despite the best efforts of some of our most visionary and talented colleagues, we've been building, investing, and

focusing on only a small part of what the internet can do to help us accomplish our missions.

Ninety percent of the universe is made of dark matter – hard to see, but so forceful that it seems to move every star, planet, and galaxy in the cosmos.

And 90% of the *internet* is made up of dark matter too – hard for institutions to see, but so forceful that it seems to move humanity itself.

Fast forward 40 years from Vera Rubin's first spiral galaxy measurements in 1967, to January 1, 2007. On that day, Hank Green, an environmental writer and web consultant living in Missoula, Montana, uploaded a YouTube video in which he bet his brother, writer John Green, living in New York City, that they could go an entire year without texting, sending email, or exchanging written words with each other, in any form. Instead, Hank proposes, they will communicate only through YouTube. They call the effort Brotherhood 2.0 ("365 days of textless communication") and you can see a short mashup of their first two messages, as well as links to the entire *oeuvre* of Brotherhood 2.0 videos.[4]

These are not high-tech productions and Hank and John Green are not movie stars. It is evident from watching 30 seconds of any of their videos that they are nerds, and they proudly describe themselves as such. If you announced to your museum director or boss that you intended to hire Hank and John Green to make a series of charming and nerdy videos about literature, art, global warming, politics, travel, music, or any of the other things that Hank and John make videos about you would be thrown out of whatever office you were sitting in and probably be asked to find another job.

But over the course of the 3,000-plus Brotherhood 2.0 videos recorded to date, Hank and John Green – or the *Vlogbrothers*,[5] as they've titled themselves and their YouTube channel (a *vlog* is a video blog) – demonstrate an exquisite mastery of the dark matter of the internet. They didn't start by making a website. They didn't develop a mobile app. They didn't have a marketing budget, a content review committee, or a brand strategy. They sat down in front of their cameras and started talking about the things that interested them, and in the process, they got to know their audience. Their work is social, graceful, spontaneous, humble, funny, creative, humane, and generous. And from the perspective of formal institutions, used to working with professional content developers, actors, videographers and web developers, it all looks like a joke.

But look at what happens over the course of the years as the brothers Green move their experiment forward:

- They create the Vlogbrothers YouTube channel.
- They discover that people are interested in what they do, and they start interacting with their followers.
- They start referring to their followers as nerdfighters – nerds who fight "to reduce worldsuck," i.e., bad things in the world.
- They begin noticing that the nerdfighters are interested in social causes.
- They encourage nerdfighters to donate money to certain charities. (The nerdfighters respond with great enthusiasm.)
- They incorporate the Foundation to Decrease Worldsuck, Inc., a Montana-based 501(c)3 charitable organization,

to receive and re-distribute the charitable donations of
nerdfighters.

· They create the Project for Awesome, an online film
festival in which nerdfighters submit short YouTube
videos promoting their favorite charities. In 2014, the
Project for Awesome raised $1,279,847 for the Founda-
tion to Decrease Worldsuck, which then redistributed the
money to charities chosen by the nerdfighter community.

· They begin talking about Kiva, a non-profit microfinance
organization that lets individuals make small, short-term
loans to low-income entrepreneurs around the world.
The nerdfighters respond, and to date the nerdfighters
Kiva group's 49,113 members have made 207,668 loans
totaling over $6 million.

· Hank Green, noticing that there was no gathering for
creators and fans of YouTube videos, starts the VidCon
conference. In its first year (2010), VidCon sold out its
1,400 seat venue at the Anaheim Convention Center.
(In 2015 Vidcon filled its 19,500 seat venue in the Anaheim
Convention Center.)

· John and Hank sell out Carnegie Hall for an event titled
An Evening of Awesome in 2013.

· With a grant from Google, they create Crash Course,
a YouTube channel of short, educational science and
humanities videos targeted at advanced high school
students. Topics include *Ophelia, Gertrude, and Regicide
– Hamlet II* and *That's Why Carbon is a Tramp: Crash Course
Biology #1*. Crash Course now has 3.4 million subscribers
and 272 million views.

· To sustain Crash Course after the Google grant ran out,

they create their own crowd-funding platform, *Subbable*, which allows people to support ongoing creative projects with small monthly donations – including donations of $0. (John Green: "Because people who are struggling financially have enough trouble in their lives without feeling that they can't fully be part of something that matters to them, simply because they don't have money.") Subbable recently merged with Patreon, and together the Subbable/Patreon community includes 250,000 people who have donated over $25 million dollars to support more than 10,000 projects.

· They create DFTBA Records ("Don't forget to be awesome"), an online store that features fan merchandise designed by and for nerdfighters. 2014 sales surpassed $2 million.

· John's behind-the-scenes collaborator and wife, Sarah Urist Green, a curator at the Indianapolis Museum of Art, creates *The Art Assignment*, a YouTube channel (produced by the Public Broadcasting Service's Digital Studios) in which Sarah and John teach people about the concepts of contemporary art by challenging viewers to create, share, and discuss their own works and experiments. *The Art Assignment* has 111,339 subscribers and 2,428,674 views.

When I checked this morning, the Vlogbrothers' YouTube channel had:

· 2,661,697 subscribers.
· 564,125,311 views.

The Vlogbrothers network of 32 channels (just stop and think about that for a moment: two nerds built their own network, with 32 channels in it) has 7.4 million subscribers and has received over one billion views:

- They have eight times more views and three times more subscribers than the Oprah Winfrey network's channel. Note that Oprah Winfrey is a billionaire and an international celebrity. (John Green is a best-selling author of young adult fiction, but he's no Oprah Winfrey.)
- They have 106 times more views and 759 times more subscribers than the Louvre's YouTube channel, and the Louvre is the most visited museum on earth.[6]

To summarize: in seven years, two lovable nerds used YouTube and their own creativity to build what amounts to a vast educational content community that any museum or cultural institution on the planet would be proud to call their own. They've got millions of avid followers, they've helped give millions of dollars to charity, they've elevated and sustained a discourse about culture, science, thought, suffering, and existence – and they're having a blast and making people happy.

They – two nerds – did this in seven years. I've been on website redesign projects that lasted seven years. I've been on committees that took seven years to write a report.

But you've probably never heard of the Vlogbrothers or Brotherhood 2.0. Hank and John Green are working in, and they're part of, a kind of internet production – a kind of interaction – that is difficult for institutions to think of as legitimate, sufficiently respectable, educational, scholarly, or erudite.

But it seems that the public doesn't care. It's likely that the public doesn't think of what memory institutions often do as being sufficiently accessible, smart, joyous, attentive, generous, welcoming, imaginative, bold, educational or meaningful to merit much of their attention.

In the 1990s, researchers from the Urban Institute conducted a study of arts and culture participation in underprivileged communities in Oakland, California.[7] When they surveyed local residents to find out where they got their culture, they were met with blank stares and a general reply of "we don't have that kind of stuff around here." But when researchers returned a few months later and asked the question a different way; 'Who are the creative people in your community?' they received an outpouring of information about the artists, musicians, writers dancers, and other creative people who lived nearby. The problem wasn't a lack of culture in the community, it was that people weren't associating their creative lives with the galleries, museums, concert halls, and other formal arts institutions that were created and operated on their behalf.

In a similar vein, the organization UX for Good[8] held a "design challenge" workshop in Washington, DC in February 2014 to help generate new approaches to accomplishing the mission of America's National Endowment for the Arts. Seven teams of information architects and user experience designers were invited to invent projects, processes, and programs to "support the arts in every community in the United States," as their brief stated. They were told they would have the equivalent of the NEA's $130 million annual budget, staff of 162 people, and national network of experts – *but they were*

not told that the project was for, or about, the NEA, or that NEA officials were in attendance. When the teams reported back, none of their concepts proposed to use any aspect of the existing cultural infrastructure that the NEA has spent the last 50 years helping to build. In the minds of those designers, America's cultural institutions – its museums, symphonies, operas, ballets, performing arts centers, and other cultural attractions – *did not seem to be an asset that would help them support the arts in every community in the United States.* (NEA acting chairman Joan Shigekawa and UX for Good co-founder Jeff Leitner, both present at the workshop, told me they were humbled and inspired by these results.)

Online it may be no different. The UK's 40 biggest cultural venues attract less than 0.04% of UK web traffic, observed Culture 24 Director Jane Finnis in *The Guardian* newspaper last year, in an article titled "Why your cultural website is rubbish."[9]

Internet Archive founder Brewster Kahle said of America's academic and research libraries, "The people who are supposed to be doing universal access to knowledge, and are getting $12 billion a year to do it, are not getting the job done."[10]

Some of the disconnect between what institutions could do online and what they do do online can be attributed to the *clothesline paradox,*[11] a term environmental pioneer Steve Baer coined to describe the phenomenon in which activity that can be measured easily (like drying your clothes in an electric clothes dryer) is valued over equally important activity that eludes measurement (like hanging your clothes outside to dry.) The same can be said for the way in which institutions habitually value activity such as visits to museums or journal

articles published by their scholars over equally meaningful but more difficult to measure activity such as the sharing of museum-related materials on social media sites or the creation of Wikipedia pages.

In his 2012 essay, *Measuring the impact of the sharing economy*, Tim O'Reilly writes, "it's quite clear to me that there is a new economy of content that is quite possibly larger than the old one, but just not as well measured, because we measure value captured, not value created for users."

Erik Brynjolfsson's research at the MIT Center for Digital Business indicates that "the value of free internet goods in 2011 was about $300 billion – and increasing at a rate of about $40 billion a year."[12]

The opportunity here is tremendous, and the experimentation that's happening in the museum, library, and archive community is encouraging. But the question now is how to get these experiments to scale *up*, to more users, and *out*, to more of our industry. Leaders of cultural technology projects often tell me that they have to fight tooth-and-nail for every dollar of funding and every "yes" of permission from their superiors. Even for projects that are considered to be successful, project teams are painfully aware of how much more they could be doing to scale the impact of their initiatives, if they had adequate support. A director of a digital media group at a major metropolitan library system told me of a recent award-winning project that took two years to bring to fruition: "It's been great, but we should be doing ten of those a year."

The difference between small, safe experiments and significant accomplishments at scale is not just a matter of perceiving the glass to be half empty or half full. The disconnect here is

that the glass – the internet and the dark matter of open, social, read/write culture – is so much bigger than we are accustomed to seeing and thinking about. The glass is huge, and it keeps getting bigger, every day.

In *Cognitive Surplus*, Clay Shirky asserted that among the educated, internet-connected inhabitants of planet Earth, there are one trillion hours of free time every year that could be used for community action, civic engagement, and learning.[13] But when Shirky published *Cognitive Surplus* in 2010 there were only 2.1 billion people online. More than a billion people have joined the internet since then. And in *The New Digital Age*, Jared Cohen and Google chairman Eric Schmidt predict that another five billion people will come online in the next decade.[14] Even using the gigantic numbers that astronomers use to describe the universe, its difficult to comprehend the combined cognitive abilities, expectations, and desire for learning, participation, and self-improvement that six, seven, or eight billion people on the internet might have.

This is a critical issue that institutions will be contending with for decades to come: There's just an enormous, humongous, gigantic audience out there connected to the internet that is starving for authenticity, ideas, and meaning. We're so accustomed to the scale of attention that we get from visitation to bricks-and-mortar buildings that it's difficult to understand how big the internet is – and how much attention, curiosity, and creativity a couple of billion people can have:

- By 2011, **Facebook's** collection of photographs had reached 140 billion images, which was reported to be 10,000 times larger than the online image collection of the Library of

Congress.[15] Two years later Mashable reported that Facebook's image repository had reached a quarter of a trillion photos, with 350 million new photos being uploaded every day. In the Spring 2014 issue of *Aperture* magazine, Lev Manovich wrote, "The photo universe created by hundreds of millions of people might be considered a mega-documentary, without a script or director." (Given Facebook's track record with user privacy, I hesitate to hold it up as an example in a discussion of open, participatory practices, but the scale of activity is so impressive that it can't be ignored. Furthermore, Facebook is an important channel for many smaller institutions.)

- **Reddit** had over 202 million unique visitors last month (September 2014), and an astonishing 7.8 billion page views. This is not simply lowbrow entertainment; the top Reddit *Ask Me Anything* discussions have been with Barack Obama, Sir David Attenborough, and Bill Gates.[16]
- In 2013, recording artist Moby[17] distributed his latest album as an openly licensed **BitTorrent Bundle**. TechDirt reported that he "got an astounding 8.9 million downloads of his offering – with 419,000 of them agreeing to join his mailing list and 130,000 of them going over to iTunes to the album (many of which likely resulted in sales)." Fans have created more than 68,000 remixes of his songs.
- In two years, **Pinterest** has grown from a concept to serving tens of billions of page views a month.[18] As of April, 2014 they were reported to have 30 billion pins on 750 million boards.
- People upload 1.2 billion photos to the top four mobile social sites every day.[19]

- **Library.nu**, a peer-to-peer book sharing service, may have been the best free online library in the world.[20] (In 2012, a coalition of publishers got a German court to shut it down on charges that it violated copyright.) An Aljazeera commentary reported that Library.nu contained between 400,000 and a million free books, mostly "scholarly books: textbooks, secondary treatises, obscure monographs, biographical analyses, technical manuals, collections of cutting-edge research in engineering, mathematics, biology, social science and humanities."
- **TED** served its billionth TED talk video in 2013.[21]
- The **Kickstarter** community has contributed over $2 billion for new creative projects.[22] Among the projects supported is the delightful *Mini-Museum* by Hans Fex. Mr Fex's fundraising goal was $38,000: he raised $1.2 million from over 5,000 backers.[23]
- **Wikipedia** and the Wikimedia projects have received over 2.2 billion edits from users.[24]
- The art history website **Smarthistory at Khan Academy** had over 5.5 million video views from more than 200 countries in 2015.[25] The Khan Academy itself reaches twelve million learners a month with its free online classes.[26]
- MIT's **Open Courseware** project served 100 million people in its first decade and their goal is to reach 1 billion learners in the next ten years.

"We used to define the value of an artwork by its frame. It's in a museum. It's validated by critics. It's priced by a label or a store. It is owned. And so on. And not really, any more..."

wrote Matt Mason, BitTorrent's Chief Content Officer.[27] "We've been watching our art objects become social objects. 2013 was the year that it stuck. Content has finally caught up with the internet: value = virality."

What makes these sites tick? For many of them, it's a strategy of openness and generosity – a genuine respect for, interest in, and admiration for the people who participate. It's an ongoing commitment to listening, respect, and empathy that manifests itself in every decision and strategic choice, and which benefits both the participants and the convener. TED founder Chris Anderson puts it this way:[28]

So, at TED, we've become a little obsessed with this idea of openness. In fact, my colleague, June Cohen, has taken to calling it "radical openness," because it works for us each time. We opened up our talks to the world, and suddenly there are millions of people out there helping spread our speakers' ideas, and thereby making it easier for us to recruit and motivate the next generation of speakers. By opening up our translation program, thousands of heroic volunteers – some of them watching online right now, and thank you! – have translated our talks into more than 70 languages, thereby tripling our viewership in non-English-speaking countries. By giving away our TEDx brand, we suddenly have a thousand-plus live experiments in the art of spreading ideas. And these organizers, they're seeing each other, they're learning from each other. We are learning from them. We're getting great talks back from them. The wheel is turning.

But is a TED talk as good as a museum visit? Is any online experience as good?

There's a lot of doubt among museum leaders that online experiences can be as authentic or impactful as a visit to a museum. But try Googling *TED talk made me cry* (my favorite is The Full Epic of Ed Gavagan) and then read "Art Museums and the Public", a 2001 report by the Smithsonian Institution Office of Policy and Analysis, which concludes:

> One of the most striking results of this generation-worth of museum audience studies is that the explicit aims of exhibition planners are rarely achieved to any significant degree. In study after study… researchers found that the central goals of the exhibition team (which are usually learning goals) were rarely met for more than half of the visitors, except in those cases where most visitors entered the museum already possessing the knowledge that the museum wanted to communicate.[29]

Art historian Beth Harris, Executive Editor and Co-Founder of Smarthistory at the Khan Academy (along with her collaborator and Co-Founder, Stephen Zucker) and former director of digital learning at MoMA, told me her own feelings about what is all-too-often the reality of museum visits:

> It isn't this amazing, contemplative, aesthetic, transcendent experience. It's jostling crowds, it's feeling hungry, it's being annoyed by the people you're with sometimes, it's feeling disappointed that you can't have the reaction that the museum wants you to have – that

you don't have the knowledge and the background to get there. I mean, it's a whole range of complicated things.

Museums and museum websites can be disappointing to people used to the more open, participatory, and playful collaborative environments they find elsewhere on the web, and sometimes they take action. Aurora Raimondi Cominesi, Francesca De Gottardo, and Federica Rossi (now joined by Alessandro D'Amore and Valeria Gasparotti) became so frustrated that so few Italian museums were online that they created their own social media movement, *Svegliamuseo* – literally "Wake up, museums!" – to inspire and encourage change.[30] Art historian and travel writer Alexandra Korey became so frustrated with the Uffizi Gallery's lack of interpretive materials, both online and in the museum itself, that she created her own mobile app and eBook to fill the void – despite the fact that she had no programming experience.[31] "If there is one museum in the world that is worth spending a lot of time in, it's the Uffizi. Unfortunately, it's not a museum that loves visitors, and that visitors love," wrote Korey. "It's a museum that desperately needs a guide... I took it upon myself to write that guide."[32]

The open, social, and collaborative platforms of the read-write web make projects like *Svegliamuseo* and Alexandra Korey's Ufizzi app and eBook inevitable, and even the largest, most brilliant institutions cannot match the wit and energy of their followers, particularly when those followers are part of a network that connects more than a third of humanity. We should expect to see countless thousands of projects like these as the internet continues to grow, platforms become more powerful and easier to use, and citizens become more

confident in their abilities to challenge, help, and even surpass the accomplishments of what have previously been sacrosanct institutions. Our choice will be whether to ignore or discourage these people, compete with them, or dedicate ourselves to ensuring their lifelong success.

"I realized the community has never been about us, Hank," said John Green in a recent Brotherhood 2.0 video. "It's been about having big conversations around big questions and lifting up people who need it." [33]

Until recently, we thought we had a pretty good idea of what museums were made of. Museums – and with them libraries, archives, and cultural and educational institutions of all kinds – were made of buildings, collections, staff, and visitors: things we could see, touch, smell, hear, or directly measure by counting tickets sold and people through our doors.

But we were wrong. Not just a little wrong. Wrong at a stupendous, almost unimaginable, scale. Like the universe before Vera Rubin discovered dark matter, we were seeing only the small percentage of cultural activity that we expected to see, where we expected to see it. But we know more now – there is more now – and it's tremendously exciting to think about what we can accomplish if we begin to work with true conviction in the areas of the internet that are less familiar to us and more familiar to our visitors.

Museums, libraries, and archives – heritage, culture, knowledge, and memory institutions – can play a huge role in the story of how Earth's seven billion citizens will lead their lives, make and participate in their culture, learn, share,

invent, create, cry, laugh, and do in the future. It is often forgotten that Tim Berners-Lee designed the World Wide Web to have a remarkable central characteristic: everyone who joined would automatically be granted the right to both consume and produce – to read, and write – on equal footing with everyone else.

"The idea was that anybody who used the web would have a space where they could write, and so the first browser was an editor – it was a writer as well as a reader," said Berners-Lee. "Every person who used the web had the ability to write something."[34] The entire architecture of the World Wide Web is based upon these humanistic, democratic ideals, and we can do a lot of good with them if we make wise choices and concentrate our efforts where they'll matter the most.

"In a very real sense, astronomy begins anew," Vera Rubin wrote toward the end of her career. "The joy and fun of understanding the universe we bequeath to our grandchildren – and to their grandchildren. With over 90% of the matter in the universe still to play with, even the sky will not be the limit."[35]

NOTES

1. The Dark Matter Mystery: Stars Are Moving Too Fast, The Science Channel. http://youtu.be/Dx1Wf84bC2M.

2. Vera Rubin: *Bright Galaxies, Dark Matter*. New York: American Institute of Physics, 1997. The physics of dark matter, and the history of its "discovery" are, of course, more fascinating, challenging, and nuanced than I've depicted here. Astronomer Neil DeGrasse Tyson has said that he doesn't even think we should call dark matter "matter", because it's so weird and inexplicable. And it's an oversimplification to say that Vera Rubin "discovered" dark matter – rather, her observations (and the work of others, back to the 1930s) seem to indicate its existence.

3. The Dark Matter Mystery: 39 Billion Missing Suns, The Science Channel. http://youtu.be/OzrxXxkdN1w.

4. Brotherhood 2.0, year 1 part 1: http://www.youtube.com/watch?v=vtyXbTHKhI0&feature=share&list=PL39A9B006C478631D.

5. Vlogbrothers:
 Channel: https://www.youtube.com/channel/UCGaVdbSav8xWuFWTadK6loA.
 Foundation to Decrease Worldsuck: http://fightworldsuck.org.
 Project for Awesome: http://www.projectforawesome.com/.
 Kiva nerdfighters group: http://www.kiva.org/team/nerdfighters.
 Evening of Awesome: http://www.nytimes.com/2013/01/17/books/john-and-hank-green-bring-their-show-to-carnegie-hall.html?_r=2&. And the webcast: https://www.youtube.com/watch?v=OPlo_T_PZsE).
 Crash Course: https://www.youtube.com/user/crashcourse.
 Subbable: https://subbable.com/.
 John Green: "…people who are struggling financially" – 2013 VidCon keynote: http://youtu.be/dYistIWBqYA [around 10:37]. Also see http://youtu.be/LNallyHtqHo.
 The Art Assignment: https://www.youtube.com/user/theartassignment.

6. http://www.cnn.com/2013/09/05/travel/top-global-museums/. And YouTube channel: https://www.youtube.com/channel/UCafm6w_rPndqAtokQy04Jdw.

7. Urban Institute: "Culture Counts in Communities: A Framework for Measurement", 2002. See pages 16 and 17: http://www.urban.org/uploadedpdf/310834_culture_counts.pdf (Also, my discussions and correspondence with project staff and consultants.)

8. UX for Good: Overview and link to design brief: http://www.uxforgood.com/project/world-ia-day-2014/.

9. Jane Finnis – top UK cultural websites: http://www.theguardian.com/culture-professionals-network/culture-professionals-blog/2013/aug/22/your-arts-website-is-rubbish.

10. Brewster Kahle: interview with the author, March, 2013.

11. Tim O'Reilly, The Clothesline Paradox: https://plus.google.com/u/0/+TimOReilly/posts/57xa79PfdTU.

12. Erik Brynjolfsson, MIT Center for Digital Business: http://www.forbes.com/sites/ericsavitz/2012/11/12/techonomy-mits-brynjolfsson-says-gdp-undervalues-free-goods/.

13. Clay Shirky, Cognitive Surplus: How Technology Makes Consumers into Collaborators. Harmondsworth: Penguin, 2010. http://www.elliottbaybook.com/book/9780143119586.

14. Jared Cohen and Eric Schmidt, The New Digital Age, Vintage, 2014. http://www.elliottbaybook.com/book/9780307947055.

15 http://mashable.com/2013/09/16/facebook-photo-uploads/.

16. About Reddit: http://www.reddit.com/about/. The top Ask Me Anything sessions: http://www.reddit.com/r/IAmA/search?q=ama&sort=top&restrict_sr=on.

17. Artists Embracing, Rather Than Fighting: BitTorrent Seeing Amazing Results. TechDirt, January, 17, 2014. http://www.techdirt.com/blog/casestudies/articles/20140117/11412925921/artists-embracing-rather-than-fighting-bittorrent-seeing-amazing-results.shtml.

18. See: http://expandedramblings.com/index.php/pinterest-stats/#.U3kpE1hdUx0 and: http://highscalability.com/blog/2013/4/15/scaling-pinterest-from-0-to-10s-of-billions-of-page-views-a.html.

19. http://ben-evans.com/benedictevans/2013/11/5/mobile-is-eating-the-world-autumn-2013-editio, slide 51.

20. http://www.aljazeera.com/indepth/opinion/2012/02/2012227143813304790.html.

21. http://blog.ted.com/2012/11/13/ted-reaches-its-billionth-video-view/.

22. Kickstarter statistics page, November 2015: https://www.kickstarter.com/help/stats.

23. Mini-Museum by Hans Fex: https://www.kickstarter.com/projects/2054592112/mini-museum.

24. http://tools.wmflabs.org/wmcounter/index.php.

25. Statistics from Beth Harris, Smarthistory, November 2015.

26. From Beth Harris, Smarthistory, November 2015.

27. Matt Mason, The 2013 BitTorrent Report. http://blog.bittorrent.com/2014/01/16/the-bittorrent-report-2013-edition/. In the BitTorrent Report, Mason continues these thoughts, quoting an essay by Rob Horning: "the point of virality is participation in the emotion of the story, and participation in its popularity. This requires a different kind of creative good. What you make has to be a call to action: kinetic, visual, detachable."

28. http://www.ted.com/talks/chris_anderson_how_web_video_powers_global_innovation.

29. Art Museums and the Public: http://www.si.edu/Content/opanda/docs/Rpts2001/01.10.ArtPublic.Final.pdf.

30. http://www.svegliamuseo.com/en.

31. http://alexandrakorey.wordpress.com/https://itunes.apple.com/us/app/uffizi-art-history-guide/id738366439?mt=8.

32. http://www.arttrav.com/florence/uffizi-app/.

33. https://www.youtube.com/watch?v=LcyCEwRb5As.

34. Berners-Lee on the read/write web, August 2005: http://news.bbc.co.uk/2/hi/technology/4132752.stm.

35. Vera Rubin: Bright Galaxies, Dark Matter. New York: American Institute of Physics, 1997, page 129.

MUSEUMS...
SO WHAT?

Robert Stein

IN AUGUST 2014, the ethicist and contemporary philosopher Peter Singer (Figure 1) wrote an op-ed piece for *The New York Times* that struck a nerve with me and with many in the arts community (Singer, 2013). In it he compares the relative value of giving to the arts with giving to charities that are actively working to cure blindness. Singer asserts that, "...it seems clear that there are objective reasons for thinking we may be able to do more good in one of these areas than in another." Furthering his argument, Singer offers a thought experiment implying that those who are willing to fund the construction of a new wing of your museum are, in essence, choosing to allow thousands to become blind. To Singer, this simple value comparison clearly favors a moral imperative to fund the tangible and immediate needs of global health and poverty over relatively frivolous cultural endeavors like museums.

You can imagine that the response to Singer's article from the cultural community was swift and loud. Dozens of articles and blog posts were written to highlight the logical flaws in his argument and to malign his brand of social philosophy, in essence dismissing the argument he presented. Certainly, I was mad too. His provocation was offensive to me. It is an affront to those of us who believe that art and culture do make an important difference. But somehow, many of those ardent responses from the cultural sector ring a bit hollow to me. While Singer's argument is directed squarely at art museums, its easy to see how he would extend this critique to the broader cultural heritage sector as a whole.

Singer's logic is clear, compelling, and important. He brings data with him that supports his conclusion and with it; he documents a tangible benefit to a global public. This

FIG. 1: Philosopher Peter Singer speaks at the MIT Veritas Forum.
Photograph: Joel Travis Sage.

doesn't change the fact that I find his idea to be deeply flawed and easily refuted. I don't believe that he's right, but others do and that's what has me worried. Singer highlights an emerging international movement called "effective altruism" whose proponents invest in charities which can deliver the biggest tangible benefits, believing that a disciplined method of investing in these causes will result in the greatest human impact for good.

Among these proponents is none other than Bill Gates, founder of Microsoft and among the most influential philanthropists of our generation (Figure 2). During a recent interview with the *Financial Times* (Waters, 2014), Gates echoes Singer's op-ed and asserts that support of the arts and culture is "slightly barbaric" using again the same flawed comparison of arts support versus curing blindness. Again, my initial response to the interview was to be angry and dismissive of these points, but as I reflected more on what was happening, I now have quite a different impression.

I have to admit some bias on my part. Bill Gates, the technologist, has not been among my favorite people. However, I must admit that Bill Gates, the philanthropist, has earned my admiration in ways I didn't expect. When one day we reflect on Gates' impact on the world, I'm quite certain that the lasting and permanent good he has done through his charitable foundation will far outstrip the impact he made on the technology industry. Gates brings a methodical, visionary, and principled approach to his philanthropic choices and it's no wonder that a philosophy of effective altruism and its data-driven approach to giving appeals to him. Herein lies the problem. If a well-reasoned, well-meaning, and generous philanthropist like Mr. Gates is predisposed to believe that giving to the arts might

FIG. 2: Bill Gates, philanthropist and technology pioneer. Photograph: Steve Jurvetson.

be "slightly barbaric", we've got a problem.

The effective altruism movement is not in and of itself a bad thing. In fact, a community of serious investors who are committed to seeing true and demonstrable impact from their giving can hardly be faulted. The problem lies with the cultural sector's inability to mount a compelling case to convince these effective altruists that tangible and meaningful benefit does indeed result from investing in the arts and culture. Our impassioned arguments about how museums can change lives and bring communities closer together are all well-and-good, but they mean very little to a data-driven philanthropist if we cannot bring supporting evidence with us to prove our point.

Proving the point: what makes a museum good?

Given that the year is now 2015, why is it acceptable for museums to tolerate such a lack of evidence for why we matter to the world around us? According to the American Alliance of Museums, the museum sector contributes $21 billion to the US economy every year. Considering that robust number, doesn't it seem strange that we still have difficulty putting our finger on the data that explains what important outcomes result from those efforts?

Stephen Weil raised the clarion call regarding the need for museums to define for themselves why they exist nearly seventeen years ago, but I feel that we've still not taken him seriously. Why should our public even care if museums are succeeding or failing if we can't prove to them why we matter?

> The good museum is neither a survival-driven institution nor a process-driven one. The good museum is a purpose-driven institution. Its leadership under-

stands and makes manifestly clear that other, more
conventional measures of success – a balanced budget,
approbation of peers, high staff morale, acquisition
of important collections – all have to do with means
and not with ends. They may be necessary to the good
museum – adequate resources certainly are – but in and
of themselves they are not sufficient to make a museum
a good one. The things that make a museum good are its
purpose to make a positive difference in the quality of
people's lives, its command of resources adequate to that
purpose, and its possession of a leadership determined
to ensure that those resources are being directed and
effectively used toward that end. (Weil, 1997.)

Weil goes on to poke his finger more deeply into the wound
we're all afraid to walk up to. What if Peter Singer is right? What
if there are some museums which don't matter, or matter less?

The first necessary step – the bold one – requires that we
publicly face up to the reality – and face up to it with a
forthrightness that has hitherto been lacking – that all
museums are not equally good and that, in fact, some
museums that manage to remain solvent and go about
their day-to-day business might really be no good at all.
(Weil, 1997: 56.)

If we care about the change that *good* museums make in the
world, we should be scouring the field for the tangible proof-
points of museum impact. We should be among the first to
volunteer our museums for studies that can begin to test

54 | *Museums... So What?*

whether we are actually making the impact we claim to be. Why do museums spend millions each year to host temporary exhibitions that will be gone in a matter of weeks, but only a fraction of that amount to study how we might do a better job of changing the world? Now that museums are beginning to have the tools and expertise at their disposal to monitor, track, record, and analyze all the various ways that the public benefits from their work, the real task begins to redesign the process and program of museums and to embed impact-driven data collection into every aspect of our efforts.

The evidence is out there

While the important impacts sought by museums are more difficult to observe and record than simply billions served or dollars at the till, the difficulty of the process does not excuse us from understanding how and why we make (or fail to make) a difference. As non-profits, museums are red-ink businesses with our most important outcomes often not well reflected in our financial bottom line. Unlike the corporate sector, museums which succeed financially may be just as likely to fail in generating meaningful impact as their cash-strapped counterparts. While the healthcare sector can count the number of lives they save, counting the number of lives changed by museums is a different task entirely.

As the value and relevance of museums is increasingly being called to question, the challenges of how best to document museum impact are questions worth answering. Increasingly, technology is allowing us to know our audiences in ways never before possible. I believe the time to model and monitor the intangible successes of museums with technology is right

now. The possibility that we might crack the code in answering these questions about museum impact would be tremendously important to our field and the people who walk through our doors.

An important word of caution is required at this point. As cultural non-profits, we should be very careful to choose the right measures to document our truly unique impacts, or risk being bitten by a snake of our own making. Perhaps the most common knee-jerk reaction when museums are pushed to make the case for their own existence is to turn to studies of economic impact. The hope is that our local constituents will embrace us with open arms if they only understand how good museums are at "pulling their weight" financially. I think we ought to be very careful not to put too much stock in this economic *raison d'être*.

Despite how true the supporting evidence may be about the economic impact of the cultural sector, the economic contribution of culture to a city does not reflect the true reasons why such a vibrant cultural community is important. By tying the value of museums to their financial footprint, we dodge the real issue at hand regarding the best and most important reasons museums should exist at all.

So what?

Museums are ideally suited to generate social impact – uniquely so. Whereas every business can compete with the museum in respect to its economic muscle in the community, very few could hope to compete with the potential social impact museums are capable of making. Besides, why would we care to win a game that isn't central to our reason for

being? What happens when our city booms around us and the fiscal imprint of our museum is no longer significant to the same degree it once was? When our city is in financial trouble, does it see museums as primarily economic assets or cultural assets? When the next recession strikes and our revenues dip, does our commensurate value to the city dip as well? I hope not.

We need culture to solve global problems

To be sure, issues of global poverty, chronic disease, human trafficking, and climate change are just a few of the serious challenges to our generation. The need for new solutions to these problems is ever-present. Spend long enough making lists of these pressing issues and you could easily be persuaded that the arts aren't worth your time and investment, but you'd be wrong.

To neglect the role of culture in the process of innovation, inspiration, and creativity is tremendously shortsighted. Consider the fact that no matter how brilliant the science or ground-breaking the discovery may be, the need to put these future innovations into practice requires working together with diverse people and cultures whose needs, concerns, and emotion demand a tolerant and empathetic camaraderie in order to make good on the promise of lasting change.

Harvard economic historian David Landes addressed this apparent dichotomy between finding solutions to these global problems and the appreciation of culture in his book *The Wealth and Poverty of Nations: Why Some are Rich and Some So Poor* (Landes, 1998). In it he emphasizes the intangible factors surrounding the economic challenges present in developing

FIG 3: Albert Einstein – a devoted musician in addition to his accomplishments in science.
Photograph: Oren Jack Turner.

nations and surmises the following: "If we learn anything from the history of economic development, it is that culture makes all the difference." In this simple observation, Landes has keyed in on one of the very tangible impacts that the arts can bring.

To solve chronic global problems we need out-of-the-box creative solutions. When IBM surveyed 1,500 CEO's about the skills they most needed in the next generation of leaders, creativity topped the list as the most crucial skill required for future success (IBM, 2010). As repositories of the world's greatest creative endeavors, museums provide a tremendous workshop for exploring creative genius both past and present. If one were to look for a place where creativity could be learned, studied, examined, and replicated in all its forms, you could scarcely do better than by exploring the collections at your local museum.

Need proof for such an audacious claim? We need look no further than the famous scientists and scholars of our time. Max Planck, father of quantum mechanics and a devoted opera composer observed. "The pioneer scientist must have... [an] artistically creative imagination" (Plank, 1949: 8). Albert Einstein and Werner Heisenberg were musicians when they weren't challenging our concepts of the universe, and Richard Feynman was creating art in between rewriting the laws of physics (Figure 3). In fact, Michele and Robert Root-Bernstein studied the effect of cultural participation among the world's great scientists and found a striking correlation between arts participation and game-changing innovation in other fields (Root-Bernstein, 2008):

Almost all Nobel laureates in the sciences actively engaged in the arts as adults. They are twenty-five times as likely as the average scientist to sing, dance, or act; seventeen times as likely to be a visual artist; twelve times more likely to write poetry and literature; eight times more likely to do woodworking or some other craft; four times as likely to be a musician; and twice as likely to be a photographer. (Root-Bernstein, 2009.)

In one of my favorite examples, noted science fiction author Neal Stephenson famously chided his fellow sci-fi authors in an essay for the *World Policy Journal*. He noted that generations of scientists had been inspired by the work of Arthur C. Clark, William Gibson, and others, but that the current generation of science fiction authors had given up on imagining a positive future world in favor of more dystopian tales:

Good [science fiction] supplies a plausible, fully thought-out picture of an alternate reality in which some sort of compelling innovation has taken place... The fondness that many such people have for [science fiction] reflects, in part, the usefulness of an over-arching narrative that supplies them and their colleagues with a shared vision... The imperative to develop new technologies and implement them on a heroic scale no longer seems like the childish preoccupation of a few nerds with slide rules. It's the only way for the human race to escape from its current predicaments. Too bad we've forgotten how to do it." (Stephenson, 2011).

Later in the essay Stephenson quotes Michael Crow, the President of Arizona State University, who prodded, "scientists and engineers are ready and looking for things to do. Time for science fiction writers to start pulling their weight and providing big visions that make sense."

Consider what could happen for a moment if museums were able to document – as universities do – our creative alumni? With the technology currently at our disposal, why are we only so focused on patron management systems (CRM by another name) which track the money people donate to us? What if we focused instead on keeping a catalog and evidence of the creative imprint our audiences are exposed to and the impact they make on the world. Such a catalogue could effectively illustrate the museum's imprint on the formation of creative ideas and creative professionals and their resulting innovation across a multitude of fields. This alumni creativity database could be a proof-text for the role of museums in the formation of creativity and a boon for fundraising linked to this important outcome.

Culture in the social framework of global communities

Putting aside for the moment the litany of global problems, we cannot neglect to consider the human framework these problems reside in and the dramatic ways in which it is changing. Driven in part by the pace of global population growth, a report from *The Guardian's* Cities Project tells us that by 2050, 70% of the world's population will live in an urban area. (*The Guardian*, 2014) To reach that place, a city of one million people will be built each week from now until that date (Figure 4).

Clearly, the urban dynamic of this future-world will bring

FIG. 4: The Dallas/Fort Worth metropolitan area recorded the largest population increase in the nation from July 1, 2011, to July 1, 2012, adding 131,879 people for a total population of 6.7M, according to the U.S. Census Bureau (March 14, 2013). Photograph: Flickr | ~Daxis.

with it a whole host of new problems as people learn how to live in harmony so closely together. The need for engaged and tolerant future citizens is urgent, but as we look at how our own cities are evolving, we seem to see exactly the opposite taking place. A study by Americans for the Arts looked at the important role civic dialog plays in the emergence of healthy democracies:

> Civic dialogue plays an essential role in the workings of democracy, giving voice to multiple perspectives on challenging issues; enabling people to develop more multifaceted, humane, and realistic views of issues and each other; and helping diverse groups find common ground.

> Yet there is growing concern that opportunities for civic dialogue in this country have diminished in recent years. Polarization of opinion along ideological, racial, gender, and class lines; exclusive social structures separating rich from poor and majorities from minorities; a sense of individual disempowerment; and the overwhelming nature of many of society's problems are all factors contributing to this sense.

> Perhaps most fundamentally, the crosscutting nature of today's complex issues often places them outside of the traditional structures and settings, such as civic organizations, labor unions, and political parties, which have served in the past to organize civic discourse. (Americans for the Arts, 1999.)

FIG. 5: Jane Addams (second from left) aboard the MC Noordam with other delegates to the 1915 Women's Peace Conference in the Hague.

The report goes on to suggest the many ways that arts and cultural organizations can play a role in encouraging civic discourse that defies these socio-economic differentiators and instead embraces the similarities we all share.

> We go to social gatherings, hoping that somehow, with somebody, we can have the real intercourse of mind with mind. – Jane Addams.

I met Lisa Junkin from the Jane Addams Hull-House Museum in Chicago at the 2012 Museum Ideas Conference in London. Although she probably doesn't know it, she really opened my eyes to all the opportunities we're missing regarding civic engagement in museums. I was struck by the way civic dialog and social justice were knit deeply into the fabric of the Hull-House Museum and with the programs that Lisa was designing and hosting there. The Hull-House Museum honors the legacy of Jane Addams (Figure 5), the pioneering feminist and social worker from the 20th century, and continues to live out her ideals.

In describing the museum's approach to civic engagement and social justice, Lisa makes the following observation in an interview for *Museum ID* (Chamberlain, 2012).

> ...[M]useums have always been an active part of civic life, helping to shape or confront cultural and political ideologies. This responsibility should never be taken lightly. The more radical museums today use their unique assets as trusted cultural institutions and repositories of history to inform and create dialogue and action around critical issues. The radical part of

museum practice comes when institutions rethink
their positions of authority. Staff must see their work as
intensely ideological, political, and relevant to today's
society.

Today, museums have so many opportunities to embrace civic
dialog as it integrates with their online presence, and many are
doing so. But, the attitude and evidence for how this online
discourse can change the fabric of our communities is mostly
missing. Certainly, the face-to-face dialog that happens in real
life at the museum is critically important, but I keep thinking
about all the ways we could enhance and improve this dialog
digitally and online. What if we considered how we might
detect when meaningful discourse happens in our social media
and online activities? How many of us are cataloging and
archiving those discussions? Why not? Rather than settling for
a "we'll know it when we see it" strategy, we can easily design
systems into our websites, Facebook pages, and mobile apps
which surpass the simple analytics common to the web today
and instead seek evidence of real attitudinal change. Why not
use sentiment analysis to characterize the tone and nature of
these discussions? Doing so could provide a quantitative index
to the attitude shifts that occur in museum audiences over
time. How about designing systems that solicit lightweight
survey data to tell us whether our online visitors are changing
their opinions, impressions, and passions along the way. Sure
this is hard, but isn't is far more important and interesting
than time on page, pages per visit, and session depth? Why are
we abdicating digital metrics for museum impact to whatever
Google Analytics decides it should provide to us? We might fail

the first few times we try, but if we got it right those answers would change the field of museums.

Creating a better community

Many of you reading this chapter will bring with you first-hand experience of how the arts can bridge cultural differences, but the cultural sector is still incredibly bad at making this case with data. Luckily, a variety of recent studies has shown how arts participation can result in increased altruism, tolerance of others, and increased civic engagement.

> If you sing, dance, draw, or act – and especially if you watch others do so – you probably have an altruistic streak, according to a study by researchers at the University of Illinois at Chicago.
>
> People with an active interest in the arts contribute more to society than those with little or no such interest, the researchers found. They analyzed arts exposure, defined as attendance at museums and dance, music, opera and theater events; and arts expression, defined as making or performing art.
>
> "Even after controlling for age, race and education, we found that participation in the arts, especially as audience, predicted civic engagement, tolerance and altruism," said Kelly LeRoux, assistant professor of public administration at UIC and principal investigator on the study. (Ranallo 2012.)

In another study, University of Pennsylvania researchers have documented that a high concentration of the arts in a city leads to higher civic engagement, more social cohesion, higher child welfare, and lower poverty rates. (Americans for the Arts)

While our nation continues to struggle to provide a quality education for all students, a lack of funding and support for the arts flies in the face of the fact that arts participation has been linked time and again to increased academic performance.

In her examination of NEA data about student academic performance, IMLS Senior Statistician Deanne Swan recently published findings that indicated children who visited museums during kindergarten had reliably higher achievement scores in reading, mathematics, and science than children who did not (Swan, 2014). Furthermore, studies commissioned by the NEA show that: "Students with an education rich in the arts have higher GPA's, standardized test scores, and lower drop-out rates regardless of their socio-economic status. Students with 4 years of arts or music in high school average 100 points better on their SAT scores." (Catterall, 2012)

In Dallas, I've been so excited to partner with a local education non-profit called BigThought. BigThought is exploring education innovation in a variety of ways, including through partnership with dozens of local arts organizations. Part of what they've shown is that students who participate in out-of-school arts activities here in Dallas exhibit more dedication to learning and better achievement scores than those students who do not. (BigThought, 2013)

BigThought is such a valuable partner to us because they have relationships with the Dallas Independent School District which individual museums and cultural organizations cannot

have. Those relationships provide BigThought with the data to measure and prove the real educational impact of cultural non-profits here in Dallas. In Summer 2015, the Dallas Museum of Art (DMA) partnered with BigThought and 50 other organizations in the city to pilot the Dallas Summer Learning Initiative. Modeled on the Chicago City of Learning project, the effort tracked the participation of thousands of school-aged kids in Dallas as they participated in a wide variety of activities.

By using the BadgeKit opensource toolkit[1] created by the Mozilla Foundation, the Dallas City of Learning project recorded detailed data about cultural participation. Can you imagine the power of coupling school achievement data with data about out-of-school participation? As pilots like these spring up across the country, museums have a unique chance to participate in gathering real and meaningful data about how their program contributes to student education and well-being.

Putting the muse in museums

Let's be clear, the evidence that museum participation can result in significant and tangible benefit to society is present and well-documented. Still, when compared to other non-profit sectors, the cultural sector is not doing a good job of making the case. Compared to curing blindness, or saving babies, we would have a tough time convincing the Peter Singers or Bill Gates of the world that investing in museums is worth their money (Figure 6).

Why do we have so few studies initiated by, or partnered with museums that seek to put data to some of these crucial contributions we can and do make? I looked for significant

FIG. 6: Students observe the Jim Hodges exhibition at the Dallas Museum of Art.

longitudinal studies about the social impact of museums and found only a few, while similar searches in the medical sector would drown us in data.

Since we know that museums – regardless of discipline – derive so much of their annual revenue from philanthropic contributions, why do we invest so much time and money seeking box office revenues and comparatively little money on evaluation to prove and improve our long-term impact? Wouldn't it make more sense to spend more time (and money) studying how museums can generate more, better, faster, and deeper change?

The time has come for museums to get very serious about a clinical examination of their effectiveness at generating value. While the measurement of the intangible elements of museum participation remains challenging, advances in technology and the ability to analyze complex systems in ways not previously possible have changed the ways we can understand our audience. The commercial sector is taking advantage of these advances to build and mine sophisticated consumer profiles with the aim of understanding your buying patterns and future purchasing behavior. Predictive analytics based on these profiles is being applied with increasing accuracy for much less laudable purposes. The time has come for museums to join the fray and to use these methods to better understand our own practice and efficiency at generating our sought-after impacts.

At the Dallas Museum of Art, we have started early experiments to gain a better understanding of our visitors and our own performance at a very individual level. In sixteen months we've welcomed more than 65,000 people in Dallas and around the country to join us as DMA Friends. In doing so, we are

growing a dataset of user profiles with actual behaviors and discrete points of data and are approaching a moment when this data will become suitably large to tell us not only who comes, but what behaviors and factors predict whether or not they will engage with art on a deeper level. As we continue to develop this dataset and our understanding of its implications on our museum's practice we will develop at least one longitudinal dataset about cultural participation. If we continue to grow at our current rate we will exceed 262,000 members in the program over the next five years and will finally know how *this* audience in Dallas relates to our museum and what *specifically* they choose to do with us. It is ridiculous to me that many museums have operated for 100 years or more knowing how many people showed up, but not a lick about why they came or what might entice them to come back. (Stein and Wyman, 2013, 2014.)

While any company that operated in this fashion would quickly go out of business, museums have had the luxury of continued existence based on the good graces of well-meaning donors. As we learned during the economic recession of 2008-2009, and more recently with the tragic bankruptcy of the city of Detroit, unpredictable economic forces can dramatically impact the financial fortunes of museums. Those museums that can demonstrate their impact with data will stand a much better chance of thriving in uncertain economic times. Even more, those same museums can accelerate their impact by improving efficiency at producing these outputs.

Unless museums can adapt their staffing and decision-making processes to move more quickly than our local cultures, we will invariably lack the ability to address the

important issues facing those cultures. In order to do this, museums need to get better quickly at understanding the vast amounts of data that are available to us now as never before. Museum executives need to think of the museum as a vast interconnected system of activity, facility, and program that can be monitored, tweaked and tinkered with. Our museums already take this call and response relationship into account when we plan for exhibition attendance and box office revenue, why not apply similar stochastic modeling to more important efforts like participation, engagement, and learning? We're good at design; so let's design the *whole* system, not just the parts that make us money.

As museums begin to gather sizable and complex datasets, we will need to employ data modeling, data mining, and statistics experts to help us. Existing museum professionals will need to augment their professional skill sets with a baseline proficiency at understanding data and using it to drive decision-making. Most importantly, serious museum professionals need to reject the glorification of and meaningless boasting about attendance and economic performance. As a field, we can no longer accept raw attendance alone as a valuable indicator of "making an impact".

Likewise, financial performance without social impact does not make a museum good. We should strive to know whether any lives were changed during the run of this exhibition. We should care enough to count whether any children who visited the museum gained confidence in their own ability to create and innovate. Do they seem themselves and their creative agency differently than before they visited? We should know whether two neighbors from our city came to understand each

FIG. 7: Vincent van Gogh, *Sheaves of Wheat.* (July 1890.) Dallas Museum of Art.

other in a new way while they visited this week. Only by measuring and counting the difference we make in people will we live up to our potential to change lives. Without it, we risk being relegated to the periphery of contemporary society as mere treasure houses for the wealthy in need of a tax-break.

If we give up on the idea that we can know for sure that our museum makes a difference, then Peter Singer is right, we're not worth supporting.

Putting aside the statistics for a moment, I feel sad for Singer and Gates. While I appreciate their desire to invest resources in methods that advance the greater good more quickly and more efficiently, their dismissal of the intrinsic value of culture makes me think they've missed out on the way art can touch a part of the human experience that no piece of data can ever measure.

> Beauty is an ecstasy, it is as simple as hunger.
> – Somerset Maugham

It seems to me that the connections between art and innovation, creativity and genius are inextricably linked. Is it possible they've missed entirely the *muse* in *museums?* A story about a young boy named Ben reminded me of this recently during a recent visit to our museum in Dallas.

Ben was born very premature and almost didn't survive. His mother and father wrestled with the fact that their baby boy might never leave the hospital. His mother hoped simply for a chance to hold him and say hello and goodbye.

Thankfully, Ben survived this rough start and grew into a vigorous and curious nine-year-old who loves to read and

explore much like your kids and mine. While Ben overcame most of those early challenges, his eyes were damaged in a way no one could predict. While Ben has grown up with sight, he is slowly going blind.

As you can imagine, knowing for sure that someday soon you will never be able to gaze on another sunset would be a lot for anyone to handle, let alone a nine-year-old boy. Ben's parents and family are a great support to him, but he clearly struggles with the fact that someday soon he won't experience the world visually any longer.

To try and make as many visual memories as possible during the time he has left, Ben and his parents have made a list. This visual bucket list is Ben's last chance at capturing memories that will last him a lifetime.

Along with seeing mountains and beaches, the Eiffel Tower, and the Pyramids, Ben wanted to seize the chance to see paintings by Vincent Van Gogh. The DMA was privileged to know about Ben and to welcome him and his family to visit the museum before hours so that they could spend some quality one-on-one time with our painting of Van Gogh's *Sheaves of Wheat* (Figure 7).

Watching Ben drink in the sight of that painting for what may be the last time is a powerful experience. Through his tears, the museum provided a memory and experience that money can't buy. Who can say how that might impact Ben, his family, or those museum staff who were there with him? This simple kindness will have a profound and lasting impact. I know I won't ever be able to see this painting again without thinking of Ben. This binding of emotion, memory, and meaning to a piece of art is fascinating isn't it?

What if we could know how to succeed like this more often? Wouldn't it be worth the effort? Don't you want to figure it out?

When Singer or anyone else reduces the value of museums to a simple equation or efficiency rating, we risk missing out on something truly special.

NOTE

1. http://badgekit.openbadges.org.

REFERENCES

Americans for the Arts. *Animating Democracy – A Role for the Arts in Civic Engagement*. 1999.

BigThought. *Enriching Minds. Growing Our Future*. 2013. http://www.bigthought.org/sites/default/files/downloads/apcommunityreport_0.pdf. Consulted November 16, 2015.

Catterall, J. S., Dumais, S.A., & Hampden-Thompson, G. *The Arts and Achievement in At-Risk Youth: Findings from Four Longitudinal Studies, Research Report #55*. Washington, DC: National Endowment for the Arts, 2012.

Chamberlin, G. "An interview with Lisa Junkin". *MuseumID*, Issue 10, 2012.

Husock, H. *Peter Singer's Seductive – And Dangerous – Anti-Charity Reasoning*. Forbes.com. August 15. 2013. http://www.forbes.com/sites/howardhusock/2013/08/15/peter-singers-seductive-and-dangerous-anti-charity-reasoning/. Consulted May 20, 2014.

IBM. *Global CEO Study: Creativity Selected as Most Crucial Factor for Future Success*. 2010. http://www-03.ibm.com/press/us/en/pressrelease/31670.wss. Consulted June 1, 2014.

Landes, D. *The Wealth and Poverty of Nations: Why Some Are So Rich and Some So Poor*. New York: W. W. Norton, 1998.

Plank, M. *Scientific Biography and other Papers*. (F. Gaynor, Trans.) New York: Philosophical Library, 1949.

Ranallo, A. B. *Interest in Arts Predicts Social Responsibility: Study*. Chicago: University of Illinois at Chicago, 2012.

Root-Bernstein, R., et al. "Arts Foster Scientific Success: Avocations of Nobel, National Academy, Royal Scociety,

and Sigma Xi Members." *Journal of Psychology of Science and Technology*, 2008.

Root-Bernstein R., M. "A Missing Piece in the Economic Stimulus: Hobbling Arts Hobbles Innovation." *Psychology Today*, February, 2009. http://www.psychologytoday.com/blog/imagine/200902/missing-piece-in-the-economic-stimulus-hobbling-arts-hobbles-innovation. Consulted June 1, 2014.

Singer, P. "Good Charity, Bad Charity". *The New York Times*, August 10, 2013. http://www.nytimes.com/2013/08/11/opinion/sunday/good-charity-bad-charity.html. Consulted May 20, 2014.

Stein, R. and Wyman, B. "Nurturing Engagement: How Technology and Business Model Alignment Can Transform Visitor Participation in the Museum". In *Museums and the Web 2013*, N. Proctor & R. Cherry (eds). Silver Spring: Museums and the Web, 2013. Consulted June 1, 2014. http://mw2013.museumsandtheweb.com/paper/nurturing-engagement/.

Stein, R. and Wyman, B. "Seeing the Forest and the Trees: How Engagement Analytics Can Help Museums Connect to Audiences at Scale." In *Museums and the Web 2014*, N. Proctor & R. Cherry (eds). Silver Spring: Museums and the Web, 2014. Consulted June 1, 2014. http://mw2014.museumsandtheweb.com/paper/seeing-the-forest-and-the-trees-how-engagement-analytics-can-help-museums-connect-to-audiences-at-scale/.

Stephenson, N. "Innovation Starvation." *World Policy Journal*, 2011. http://www.worldpolicy.org/journal/fall2011/innovation-starvation. Consulted May 20, 2014.

Swan, D. W. "The Effect of Informal Learning Environments on Academic Achievement During Elementary School." Paper presented at the annual meeting of the American Educational Research Association, Philadelphia, (April, 2014. http://blog.imls.gov/?p=4792.

Wainwright, O. "Guardian Cities: Welcome to our Urban Past, Present and Future." *The Guardian*, January 2014. http://www.theguardian.com/cities/2014/jan/27/guardian-cities-site-urban-future-dwell-human-history-welcome. Consulted May 30, 2014.

Waters R. "An Exclusive Interview with Bill Gates." *The Financial Times*, 2014. http://on.ft.com/18Jatka. Consulted June 1, 2014.

Weil, S. *Making Museums Matter.* Washington DC, Smithsonian Books, 2002.

IMAGE CREDITS

Figure 1

Source: https://commons.wikimedia.org/wiki/File:Peter_Singer_MIT_Veritas.jpg

License: https://creativecommons.org/licenses/by/3.0/deed.en

Credit: Joel Travis Sage

Figure 2

Source: https://www.flickr.com/photos/jurvetson/4368494308/sizes/o/

License: https://creativecommons.org/licenses/by/2.0/

Credit: Steve Jurvetson

Figure 3

Source: https://commons.wikimedia.org/wiki/File:Albert_Einstein_Head.jpg

License: Public Domain

Credit: Oren Jack Turner

Figure 4

Source: https://www.flickr.com/photos/daxis/18378516600/sizes/l

License: https://creativecommons.org/licenses/by-nd/2.0/

Credit: Flickr User Daxis https://www.flickr.com/photos/daxis/

Figure 5

Source: https://commons.wikimedia.org/wiki/File:Noordam-delegates-1915.jpg

License: Public Domain

Figures 6 and 7

Source: Dallas Museum of Art

License: Courtesy of the Dallas Museum of Art

LOVE YOU,
LOVE YOU NOT

Luis Marcelo Mendes

THE MUSEUM COMMUNITY in Paris woke up in shock on February 20, 1909. On the front page of *Le Figaro* Saturday edition, the Italian poet Filippo Tommaso Godoy Marinetti declared the launch of Futurism. It was a loud and bombastic manifesto that went viral *avant la lettre* and inaugurated the textual affirmative procedure of the avant-garde modernist art movements that emerged right after this.

"We will destroy the museums, libraries, academies of every kind. Museums: cemeteries!", wrote Marinetti. He went on to state that a roaring motor car running like a firing machine-gun is more beautiful than the *Victory of Samothrace*. This declaration of war on museums was a huge landmark on the problematic relationship between museums and us – the audience – since the start of modernism. Yet it was certainly not the last. Some of these declarations became juicy intellectual references, such as Paul Valéry's text *Le problème des musées*, where the museum is a dwelling place for "dead visions." Of course, some were not that sophisticated. Nevertheless, we've seen over and over again critical exercises which touch on the very same painful spot: the image of the museum as a dusty place misaligned with contemporary life.

The museum community worldwide received a shock again on August 22, 2013. As the museum blogosphere engaged in a passionate discussion about the opinion article written by *CNN Travel's* senior producer James Durston. It was unambiguously entitled *Why I hate museums*, resonating with both the lugubrious imagery forged by the futurists and Valéry's "waxen solitudes," and in it Durston describes museums as:

Graveyards for stuff. Tombs for inanimate things. Their

cavernous rooms and deep corridors reverberate with the soft, dead sounds of tourists shuffling and employees yawning. They're like libraries, without the party atmosphere. Occasionally a shrill voice bounces down from a distant hallway: "No photos!" and I swivel to see something, anything, that might be interesting. But it's not.

We may adore museums but this relationship has been quite problematic over the past century. There are a thousand stories about this love-hate relationship, mediated mainly by issues of power, control and authority of museums over objects, and the decision of what or who is worthy enough to be portrayed on those gallery walls. Of these accounts I find the futurist manifesto the most interesting of all for its declared incompatibility of museums with the emerging tech-oriented society of early modernism. And how it took over a century to overturn this discomfort to build the forms of technological experience that we see in museums today.

Especially when we consider the tool of choice in the museum is the beauty-of-speed-utopia which the futurists idealized, *living in the absolute*, now realized as the instant means of accessing information we all carry in our pockets.

It's all about control

In the beginning it was a radical idea and could not go wrong. The roots of the museum as a social institution lie deep in the Enlightenment enterprise for the creation of new knowledge and its dissemination, according to Canadian author Victoria Dickenson in her essay "Re-forming the Museum, Root and Branch."[1] Based on the innovative idea that the world might

be better known through its productions; and that through organizing them and offering public access, new understandings would be generated. As a result, by the mid-19th century, the crowds of London were already clamouring for easier access to the displays of the British Museum.

Dickenson says that the original form of the museum, founded on an ideal of inclusivity both in its material collections and its public access, was switched over to an exclusionary role which became the basis of the most trenchant criticism of this kind of institution – and an issue still under intense and global discussion today by practitioners, thinkers and activists who reclaim an "open-authority" perspective: opening collections online or searching for a deeper engagement with communities.[2]

Part of that betrayal of museums' roots can be attributed to the historical role which major European museums took upon themselves to evoke the wonder, power and glory of their empires, as embodied in objects acquired through the conquering, exploitation, acquisition, and expansion of colonies. As the PhotoCLEC project on Museums and the Colonial Past comments:

Not only were overseas collecting practices an inherent part of colonialism. At home, by researching and displaying the overseas collections, museums also offered a public justification for expansion and imperial rule, while developing a framework for intellectual understanding of self and others that became entangled with exclusive rules concerning citizenship entitlements. Moreover, together with world exhibitions, national mu-

seums came to embody competitive statements within the unstable continental European power relationships.[3]

By that time, museum leaders assumed the institutional thrones that control the objects and the stories behind them. And that worked until the 20th century brought the new creations and possibilities of the modern world's promises, as described by the American philosopher and Marxist humanist writer Marshall Berman in *All That Is Solid Melts Into Air*:

> To be modern is to find ourselves in an environment that promises us... transformation of ourselves and the world – and, at the same time, that threatens to destroy everything we have, everything we know, everything we are.[4]

Museums in this environment really must have been something to fight against and not just for the futurists. Gertrude Stein once famously said "You can be a Museum or you can be Modern, but you can't be both". It took quite some time before modernists were accepted in museums, as the Impressionists before them or the Abstract Expressionists after them found. It is instructive to note that the exhibition that marked the dawn of modernism in America – The International Exhibition of Modern Art show of 1913 – happened at the 69th Regiment Armory in New York, not in an art museum.

From the the audience's point of view a behavioral shift also occurred. From the loud crowds of common people examining the pictures in the 1840s to the very disciplined experience most of us had in our childhood, where you should dress properly, not talk, run or touch, keep your distance and try to

absorb as much information as possible.

No wonder that, over the decades, we not only kept at a safe distance from museums but also developed the fetishes of aggression (museum heist movies can be considered a genre) and transgression – best represented by the poetic, anti-authority scene in Jean-Luc Godard's movie *Bande à Part* (released just four years before Paris riots of 1968), in which the protagonists Franz, Arthur and Odile race through the Louvre.

Another movie example is John Hughes' classic *Ferris Bueller's Day Off* in which Ferris, Cameron and Sloane choose the Art Institute of Chicago as part of their day off but, curiously, enter the museum with a grade school field trip. They're seen posing, watching, pondering and even kissing in front of the art. It's a scene that puts makes us wonder: wouldn't it be nice if museums could be happy places like this?

And that brings me back to the starting point of this love-hate relationship debate: a huge number of people living on Earth have never stepped into a museum and have no plans to do so next weekend. What role can traditional institutions such as museums expect to play in contemporary society? Can they still rely on the intrinsic value of their collections? How can we propose a new deal for those who hate museums?

What a difference a day makes

I believe that both *Bande à Part* and *Ferris Bueller's Day Off* are great illustrations of do-it-yourself experiences in museums now enhanced by a variety of new technologies. Every exhibition selfie, for instance, can be seen as a tribute to this very idea. So can the increased value of the objects as they shift from the power of ownership to the power of sharing. Collective

curation, community engagement and even museum citizenship are also related manifestations.

In the current culture of open information, cultural institutions must understand that value is not created by what is secured in storage but by the data that is always available. On *Trends Watch* report, Elizabeth Merritt, founding director of the Center for the Future of Museums, says:

> Museums are deconstructing, piece by piece, the authoritarian model that presumes control of what people see, what they learn, and how they learn it. Open data vastly accelerates this trend, vaulting us into a world in which users bypass museum controls and filters and go straight to the source. That prospect can be pretty scary.[5]

Take the example of OrsayCommons, a micro-community which protested against a photography ban established in 2010 by the Musée d'Orsay in Paris "to preserve the comfort of visitors and the safety of the artworks". Through irreverent activism, the group performed demonstrations organized through social media where visitors would meet in the museum, take photos within its walls and upload them on Flickr, Twitter or Facebook, driving the security staff crazy. OrsayCommons' organizer Julien Dorra said:

> We'd love to see more people hacking their favorite museum: organizing pirate tours that the museum doesn't offer; printing alternative catalogs; offering better audio-guides to download; and, of course, setting up photography workshops in museums that ban photography! And

even better, we'd love to see museums openly embrace being hacked by their visitors – that's what we call the museum as an open platform.[6]

The tech drive, so dear the Futurists, is what may give a new relevance to these institutions today. Over the past decade, technology has slowly been transforming these institutions and opening up a wide field of possibilities – from internet of things to the popularization of 3D printing. The digital technologies that we're developing now are more likely to take us into a utopian future, not a dystopian future. The best days are really ahead.

Standing on the world's summit we launch once again our insolent challenge to the stars!

One more thing

On an ironic note, Paul Valéry is now the basis of a museum in the French town of Sète. In 2014 Italian Futurism turned its sound and fury into a major exhibition at New York's Guggenheim Museum, where it was appreciated, commented on and shared through high-speed internet. The Musée d'Orsay lifted its ban on photography in 2015 after French Minister of Culture Fleur Pellerin posted photos of Bonnard paintings she took at the museum on Instagram. And in America, the concept of "hacking a museum" became a profitable business thanks to a company called Museum Hack.

NOTES

1. Victoria Dickenson, "Reforming the Museum, Root and Branch", in *The Radical Museum: Democracy, Dialogue & Debate*, ed. Gregory Chamberlain (London: Museum Identity, 2011).

2. Open-authority is defined by digital media strategist Lori Byrd Phillips as "a mixing of institutional expertise with the discussions, experiences, and insights of broad audiences".

3. Between June 2010 and January 2012, the research project Photographs, Colonial Legacy and Museums in Contemporary European Culture (PhotoCLEC) traced the experiences of a vast range of people touched by European colonial expansion, both colonised and colonialisers.

4. Marshall Berman, All That Is Solid Melts into Air: The Experience of Modernity (reissue edition). Harmondsworth: Penguin Books, 1988.

5. *Trends Watch 2015* is a publication of the American Alliance of Museums' Center for the Future of Museums, organized by Elizabeth Merritt.

6. Julien Dorra was interviewed by the writer, curator and critic Régine Debatty, for the blog We-make-money-not-art on December, 2010.

TOWARDS THE SOCIOCRATIC MUSEUM: HOW, AND WHY, MUSEUMS COULD RADICALLY CHANGE AND HOW DIGITAL CAN HELP

Bridget McKenzie

ONE INSPIRING FEATURE of CODE | WORDS is being encouraged to write in response to others, as part of an evolving series of essays. As so often happens, my own thoughts were sparked by Nick Poole, this time in his piece *Change* (see chapter seven).

Poole responds to Michael Edson's vision of museums lifted out into a more accessible space of possibilities, not so much by technology but by people outside the museum with access to it. Poole in turn points to the fundamental changes needed to bring about this desired future. He fears museums are still "temples to the illusion of order and predictability in a complex and chaotic world", creating solitarist stories out of messy diversity. I agree with Poole's challenge that too many museums are guilty of "openwash" – where change to a more participatory culture is only peripheral. I see this openwash as part of a broader "ethics-wash" in museums, a complacency about their own ethical authenticity. This demands scrutiny, given the unfolding global crisis that museums cannot escape. I suggest that the fundamental change can only involve more sociocratic forms of practice and governance.

The ideal of a sociocratic museum is one that is radically democratic in such a way that it impacts on society, which arguably goes beyond simply a "social museum" that is expanded by digital programming and a participatory ethos. I am curious about how digital can play a role in a transition to radical democracy, especially since sociocratic principles are influenced by cybernetics. But I argue that digital alone can't achieve the necessary change unless integrated with more truly democratic, and therefore ecological, ethics of governance and methods of education.

FIG. 1: A 'drawing flashmob' of Tate Britain, organised by some home educated children.
Photograph: Bridget McKenzie.

What do I mean by "global crisis"?

Climate change is man-made and already dangerous. With current emissions, we are on course to an unliveable planet by the end of the century. The Sixth Mass Extinction is already eliminating species at 10,000 times the background rate. Human civilisation has shifted away from an ecological way of knowing, supporting an extractive economy that allows companies to exploit the living world and disrupt the climate. This current system also creates a yawning social equality gap and airbrushes over abuses of human and animal rights. As people protest more at these abuses, democratic freedoms are eroded and police are militarised.

Globally, governments are capitulating to the influence of corporations, for example by bailing banks out of debt, or providing security and subsidies for fossil fuel companies. Meanwhile, people suffer austerity measures to pay off public sector debts that arise from an unstable casino economy. As I'm based in the UK, I'm especially alert to how publicly-funded museums are faring in austerity, as we are facing a rapid dismantling of a wide range of public sector institutions. The budgets of local government are being slashed, threatening significant numbers of smaller museums, while national museums must seek more private donations and corporate sponsorship.[1]

There are, of course, movements for resistance and change. However, an orthodoxy in many movements is to encourage people to take individual action as consumers, rather than collective action as citizens. This orthodoxy is perhaps less strong in indigenous and radical movements, such as First Peoples[2] and Occupy but these are not mainstream. Unfortunately, small individual consumer actions are proving to be

ineffective in tackling this multiple global-scale crisis. This is exacerbated by the phenomenon of "pluralistic ignorance" – or the bystander effect – where people take their cues on how to behave by reading others. Most of us see others carrying on with business as usual, stopping us from forging ahead together to effect adequate change.

Grasping how technology affects us

Arguably, so far, consumer technology has been the biggest contemporary force for change that we are noticing, wherever connected devices can be afforded *en masse*. Digital is making us less physically active, less private, more exposed to new information, more globally connected, and more active in choosing, creating and contributing to content. Digital is massively impacting how we shop, design new products, collaborate on projects, do science, consume music and film, use libraries and museums, manage our education, join clubs, learn new skills, meet people and plan our travel. There is more to come – as technology is due to progress more in the next five years than in the past ten.

Compared to technology changes, the environmental-economic crisis is not greatly affecting how people function in wealthier countries, at least not in their affluent classes, just yet. In turn, digital technologies are not preventing the poorest people and countries from being hurt by the environmental-economic crisis. That said, digital technology is entangled with the crisis, and we are at a point of balance between two futures, one where digital is controlled by the powerful to perpetuate the crisis (unwittingly or not), another where it is harnessed by collective citizens to overcome it.

Evgeny Morozov points to the sinister side of digital, arguing that governments are creating a "technocratic utopia of politics without politics".[3] He believes governments are deregulating and privatising state institutions in hopes of gaining algorithmic control over us, using narratives, nudges and surveillance to mould the good citizen as a panacea to many problems.

This digital solutionism might seem efficient. We might hope – with some justification – that participation in culture can be optimised with digital services to bring all kinds of social and educational benefits. We might hope that digital will herald the people's revolution, let us take control of money, knowledge and justice. The problem is that most of us become so succoured by gadgets, and lured by smart consumer technology into a belief that we are making a difference, we fail to notice the dire state of affairs unfolding beyond our devices. Our devices ever more vividly expose stories of poverty, floods, droughts, protests and wars but we fail to act directly or effectively enough. Our default response, especially if we're early adopters or designers of digital services, is to ask "is there an app for that?" If states shrink, with governments relying more on data to control us and on culture to nudge us, how can museums contribute to that while retaining the ethical authenticity they hope is theirs?

How the crisis impacts on museums

The context is paradoxical, one of rapid progress mixed with unfolding collapse. Museums are pulled in two directions. They are enticed by technological progress – and the glimpsed vistas of consumer and corporate wealth it offers. However,

they struggle because they exist to preserve heritage for posterity, and unfolding collapse will be requiring their emergency services. There lies the rub in the dematerialised digital ideal of museum. If the ultimate sociocratic museum only succeeds in cyberspace, how will we ensure that people participate fully in interpreting and caring for real places of significant heritage? If people get a (proxy) sense of agency within their compelling digital networks, will they be less willing to support real places or resources that are threatened by austerity, conflict or natural disasters?

What kind of emergency services do museums actually perform? Museums enable diverse communities to discover, perform and perpetuate heritage over the long term. This is in direct contradiction to the dominant plutocracy who prioritise short-term profit returns over both the sustainability of the historic and natural environment, and the open-ended potential of art and science. Facing this plutocratic opposition, museums have a hard job to advocate their core function, and that's exactly why they must work harder to engage the public. Museums can offer the best conditions for "affective germination" – stirring meanings and emotional responses to things, places and ideas – to remind people why heritage matters. Part of this is broadening the recognition of what counts as heritage, including the ephemeral, demotic and marginal, the non-human and the overlooked. John Russick's chapter, *A Place for Everything*, for example, imagines collections reframed in geo-spatial terms, with all objects from a place mapped to multiple locations helping to connect people to objects and places by making them more meaningful. The more people feel these connections, the more they can support the long cycle of

care. However, it is essential that once drawn in by such tools as mapping apps, or any kind of participatory programming, the right structures are in place for people to engage step by step – to learn more, to build networks around interests, to give their time and to become stewards of heritage. I suspect that the more focused museums are on short-term and quantifiable outcomes, the more likely they are to fail in building these structures for progressive participation.

Museums tend to take a long view, which is one of their most positive assets. However, a whole new light is thrown on their long-termism by the fact we can no longer assume the continuity of human civilization. (Or perhaps that's a whole new dark shadow!) Should museums get even more radical in their emergency services? Should they focus on creating an ark of cultural knowledge and biological data, so that surviving humans can rebuild civilisation? Or throw everything urgently into the challenge of bringing about a sustainable society? Or offer a service of cultural therapy, which could be termed "palliative curation", as more certainty is lost? Any or all of these options are perhaps necessary for any cultural institution to face the reality of the global crisis while retaining any sense of authenticity.

Unfortunately, such a stance is not seen to be realistic when part of this reality is austerity and cuts to museums. The fittest museums – whose examples we are asked to follow – are seen to manage by targeting more wealthy consumers, accepting more corporate sponsorship (no matter who from) and making cuts to education and outreach. However, I'm not sure how lasting these solutions are, or how appropriate they will be for more community-based museums.

FIG. 2: After a performance by Liberate Tate, at the BP-sponsored Tate Britain.
Photograph: Bridget McKenzie.

I've argued in several articles[4] that for museums to thrive in troubled times, they must radically reinvent themselves. Creating the museum of the future is not about following trends but accounting for critical incidents such as natural disasters, crashes, new social movements or game-changing inventions. The conundrum, of course, is that these are all impossible to plan for, by their nature. Given this, they at least need to adopt a "precautionary" mindset, an awareness that big and unpredictable waves of change are round the corner. They also need to develop programmes and governance models that positively game the system to favour the unpredictable outcomes of creative practice, and promote their vital role in the sustainability of heritage, ecology and diversity. For example, Robert Stein, in his smart chapter, *Museums... So What?* on how museums can demonstrate social impact, suggests that museums don't just use data to capture how much patrons give but how much their cultural experience leads them to make creative innovations. Generating creative and "thrivable" mindsets in people is a valuable outcome.

Three museum models

I only have tentative answers for how this radical reinvention could be achieved, and would love to see ideas in response to this. But I do have a sense of an ideal, which is that museums could be more sociocratic. To explain this further, it might help to see sociocracy in relation to two other museum models.

One of these other models is the plutocratic museum. This may have been established by an individual ruler or corporation. Historically, and even today, its collections are likely to be funded largely by the spoils of war, of human exploitation and

environmental extraction. Conserving, commissioning and making these riches accessible are a form of "culture-washing" to justify the plunder by which they appear. Its buildings may be palatial and iconic, and audiences are seen as subjects. Examples include the Louvre Abu Dhabi and Guggenheim Abu Dhabi, the subject of activist protests about degrading labour conditions in their construction.[5]

The model most familiar to me in the UK and Europe is the bureaucratic museum. Its collections may have originated in plutocratic plunder, but as states have expanded institutions for public good, museums have emerged as "jewels in the crown" of national and civic culture. It operates in organised hierarchies, to be efficient yet fair in its service to the public. Increasingly its relationship to corporate power is becoming problematic, as state museums are being encouraged to accept philanthropy to replace public funds. Along with their conflicted relationships, they perceive two groups of audiences, one as clients who receive public services, the other as consumers. One example is the Smithsonian, a museum institution dedicated to the public good, but not above accepting major funds from the Koch brothers, the oil barons who fund and perpetuate climate denial. A similar example is Tate, increasingly criticised for its relationship with BP (Figure 2).[6]

The third, then, is the sociocratic museum. In ideal form it goes beyond participatory tactics towards governance that is non-hierarchical, consent-based and rooted in its communities. We may see these principles beginning to appear in independent museums run by trusts or co-operatives, or as social enterprises. Such organisations are driven to preserve overlooked or threatened heritage, or to further a social cause

or an aesthetic practice. Their audiences are seen as citizens and collaborators. The governance of sociocratic museums may not be perfect, perhaps drowning in committee meetings, or perhaps in senior staff dominating decision-making due to passion and high standards despite participatory principles. However, these few museums can offer glimpses of practice whose time has come. Economuseums offer a good example of sociocratic yet commercial museums.[7] They are run by collectives of crafts people or community heritage groups, and they raise funds in self-reliant ways through workshops, exhibitions and selling artworks. Another inspiring example towards sociocracy is the approach taken in the remaking of the Silk Mill in Derby, where visitors and volunteers are invited to become citizen curators, learning skills as they make the display fabric as well as interpretive content of the new space.[8]

What can digital do?

I think the key is not in the familiar question "How can museums survive?" but in "How can museums do work that matters?" and "How can our governance reflect our mission?" In a crisis, I would argue that education and therapy are the most important emergency contributions cultural services can make. I strongly agree with Mike Murawski in his chapter *The Moon Belongs to Everyone* about embracing a digital mindset from the perspective of being a museum educator, a background I share with him. A digital mindset is really a connected mindset, which means building on all the ways digital is integrated into how people explore and learn.

Naomi Klein suggests that, "The Museum of the Future should be a genuinely multidisciplinary space, so if we're

FIG. 3: Involving local people in curation is at the heart of remaking the Silk Mill in Derby.
Photograph: Derby Museums.

talking about climate change it wouldn't just be talking about climate change as a problem of too much carbon in the atmosphere but about why it's there and who the interests are behind it and what the real, structural barriers are to progress."[9]

If this is right, museums as educators must be more honest about the root causes of change, which means being more "systems-literate". Digital plays a role in systems literacy, by offering infrastructure for people to connect (non-hierarchically), to build consent about science, to accelerate learning, or to share "positively deviant" ideas for change. It can combine big data with deep narratives to explore geopolitical and human-ecological stories throughout history. Systems-literate museums may help communities be self-reliant and maintain wellbeing as the crisis hits home, much as the Happy Museum Project aims to demonstrate and measure.[10] Museums may then be more valued as a result of doing more valuable work, not just by existing. If they stop assuming that museums have an inherent purity and public good effect, they are less likely to offer culture-wash to unethical sponsors or patrons.

So, is the social web powerful enough to trigger such a reinvention of museums? Is it possible for a big, bureaucratic or plutocratic museum to be radical enough to challenge business-as-usual? Is there a will in museums to be on the side of the people, using digital to resist the perpetuation of crisis?

I don't know, but it might well be that digitally-enhanced people-power in response to unfolding events triggers a series of movements leading to change. The #MuseumsRespond-toFerguson initiative that emerged in 2014 offers an encouraging sign of this.[11] A joint statement by museum bloggers led to real actions by museums, amplified by social media. In

turn, other galleries are joining the movement, such as Smack Mellon in Brooklyn with its open call to artists to Respond.[12] This sentence from the bloggers' statement sums up how museums can do work that matters:

> As mediators of culture, all museums should commit to identifying how they can connect to relevant contemporary issues irrespective of collection, focus, or mission.

Perhaps, in months and years to come, people will start to demand that their museums respond to terrorist massacres, to climate talks and climate disasters, to global food shocks and mass migrations of refugees, to the extinction of the white rhino...

NOTES

1. http://www.museumsassociation.org/campaigns/funding-cuts/fighting-the-cuts.
2. http://firstpeoples.org/.
3. http://www.theguardian.com/technology/2014/jul/20/rise-of-data-death-of-politics-evgeny-morozov-algorithmic-regulation.
4. For example https://thelearningplanet.wordpress.com/2012/05/08/seeing-museums-in-2060/.
5. http://www.dissentmagazine.org/article/1-museum-the-guggenheim-goes-global.
6. http://www.liberatetate.org.uk/.
7. http://www.artisansatwork.ca/portal.php.
8. http://remakemuseum.tumblr.com/.
9. From the Museums of the Future project by the Natural History Museum: https://www.youtube.com/watch?v=AmFL06jAYg0.
10. http://www.happymuseumproject.org/.
11. http://www.museumcommons.com/2014/12/joint-statement-museum-bloggers-colleagues-ferguson-related-events.html.
12. http://smackmellon.org/index.php/exhibitions/respond/.

MUSEUMS AND #BLACKLIVESMATTER

Aleia Brown and Adrianne Russell

IN THE EARLY nineteenth century, a small population of free people of color speckled the United States. Some of them did not disrupt the status quo, but revolutionaries like Denmark Vesey of Charleston, South Carolina called for the nation to burn.

A founding member of Emmanuel AME Church, Vesey primarily recruited church members for the insurrection. His plan leaked to slave owners before he could make Charleston a site of liberation. The Mayor organized a militia to catch all co-conspirators. Vigilante justice reigned over the city, also enforcing white supremacy. The goal to maintain this social hierarchy seemed to fade as years went on, but some kept the sentiment close.

On June 17, 2015 self-proclaimed white supremacist Dylan Roof reignited that spirit of vigilante justice and murdered nine Emmanuel AME Church parishioners with the intent to start a race war nearly two centuries after Vesey planned his uprising.

Black people have long struggled for their freedom and civil rights in America. Denmark Vesey is an example of this. Therefore, African-American uprisings across the nation after repeated incidents of white police officers shooting unarmed black citizens is not just an inciting 2015 headline. It falls on the continuum of black people protesting against state sanctioned violence and over-policing in their communities. So why do museums hesitate in responding to Ferguson and Baltimore?

Are museums really ready to respond to Ferguson?
In her chapter *Towards the Sociocratic Museum*, Bridget McKenzie proposes a new model of museum to counter the existing plutocratic and bureaucratic archetypes that have arisen from plunder and oppression or are discomfitingly in bed

FIG. 1: Black Lives Matter Protest, Mall of America, December 2014.
Photograph: Wikimedia.

with problematic corporate entities. In theory, the sociocratic museum would forego being participatory and engaging on its surface to make way for "governance that is non-hierarchical, consent-based and rooted in its communities." Recently, museums have championed inclusion and engagement. But the digital landscape and communities of color have pushed back, creating spaces which discuss their lived experience and critiquing how other people view it.

McKenzie's piece cited #museumsrespondtoferguson,[1] a Twitter chat which the authors co-host on the third Wednesday of each month, as an example of how people-driven movements in the digital realm can inspire change in museums. In 2014, tens of thousands of Americans took to the streets protesting the killings of unarmed black citizens by police in Staten Island, Beavercreek, Ferguson, Cleveland, Baltimore (and unfortunately many more in subsequent months). These actions were inspired, organized, shared (and ultimately spied on)[2] via a host of digital platforms, most notably Twitter. The micromessaging social network, which has the highest percentage of black adult users according to recent research,[3] is the digital equivalent of an old-school office water cooler. It's where news breaks, information is shared, and racist tomfoolery is dragged to the carpet.[4]

Claiming their space digitally

#BlackLivesMatter, and other movements, rallied marginalized people and amplified their unified voices. They claimed virtual space instead of waiting for it to be doled out to them. Traditional gatekeepers were rendered moot. Schools, arts organizations, libraries, and other entities responded with

FIG. 2: Black Lives Matter Protest. Photograph: Wikimedia.

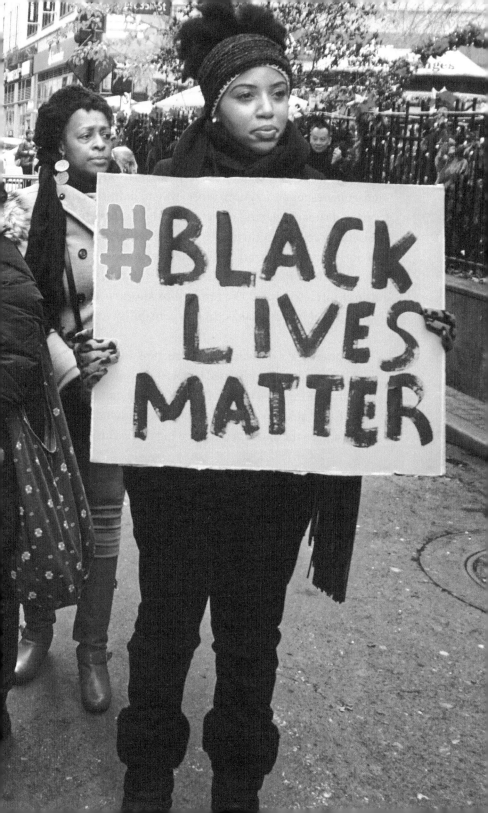

public statements denouncing police brutality, presented related programs, or offered their venues as community gathering spaces.

The *Joint Statement from Museum Bloggers and Colleagues on Ferguson and Related Events*,[5] from which #museumsrespondtoferguson arose, was an industry call-to-arms, primarily asking museums in the United States to similarly reflect on their internal oppressive practices and actively demonstrate their roles as change agents fully embedded in our nation's social, educational, and cultural infrastructure. The forward to *Museums, Equality, and Social Justice*[6] makes this responsibility explicit:

> No matter what a museum's legal structure, whether publicly funded, or authorised by society to function as a charity, it is expected to contribute to the common good. If its basic values do not include solidarity with the excluded, then the museum is reinforcing that exclusion.

Museums pride themselves on embodying this "common good", on honoring its social compacts, and on being physically and virtually relevant. Precious resources are devoted to engagement, a term so buzzy and overused that it often elicits groans and eye-rolls from museum employees tasked with bringing the nebulous concept to life. These colleagues regularly communicate via tags such as #musesocial, #musetech, and #museEd to crowdsource solutions and exchange practices, so convening in digital spaces isn't new. However, using those spaces to openly examine anti-blackness in museums certainly is.

Twitter: the tool for activists online

Social activism is inherently risky but protest in the physical world can take place with a certain degree of protection. You can demonstrate outside of work hours or anonymously donate to causes of your choice. But participating in a Twitter chat explicitly dedicated to confronting your current or potential employer's systemic oppression under your personal account, which might even include your image (and almost overwhelmingly some variation of a "these ideas are mine alone" disclaimer), is practically an act of rebellion in an industry with a long history of conformity, exclusion, and aversion to transparency.

The *Joint Statement* was born digital and continues to live online, making it more accessible than a paper document. Museums responding to overarching themes like race, police brutality and community relations dominate the online landscape now. The monthly Twitter chat is a limb of the statement, keeping the conversation alive. Twitter has been the most appropriate online social media platform seeing that it is the most immediate and democratic. Facebook, the most popular social media platform, originally started exclusively for Harvard students. Eventually, it expanded to a service for all Ivy League schools along with Stanford University. It was not until 2006 that anyone of appropriate age could join the site. Contrarily, Twitter has always allowed anyone with a valid email address to join the site. Anyone can build a sizeable audience without educational, economic or social weight.

Twitter is also useful in the sense that it is immediate. It is a space for discourse and thinking aloud in public. And it has a record for social change. Among many others, Egyptians

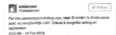

FIG. 3: Twitter introduced new perspectives and sources outside the mainstream to some of our chat participants.

most notably used Twitter in 2011 to organize actions in hopes of overthrowing President Hosni Mubarak. Its record for serving as a platform for social change made it the top choice for housing #museumsrespondtoferguson.

The Storify shown at Figure 3, which focused on museums and oppression, illustrates how Twitter introduced new perspectives and sources outside the mainstream to some of our chat participants. Margaret Middleton noted, "#BlackLivesMatter has completely transformed the way I see the world." Through these chats, Twitter continues to demonstrate to us that we can spread information that disrupts traditional narratives quickly and effectively.

The stutter-step between hashtag and action

As good as Twitter is, it still presents some challenges. How do we move out of an online safe space, to a space of action? We did not even provide a Storify for our fifth chat which asked participants to share anti-blackness work they have engaged since being a part of #museumsrespondtoferguson. There were barely any tweets to archive. Instead of seeing action, that particular chat pulled back a veneer and exposed fear and tepid hopes. After several chats, it seemed like participants were still unsure about how to respond to Ferguson. We have pushed for museums and museum professionals to first examine the ways they perpetuate or dismantle oppression. Before museums can truly engage communities, they have to do the internal work. To be sure, this work is not easy, and it is far more complex than providing a tidy and succinct list of ten steps to engage with the black community.

Some comments, like one that relegated

#museumsrespondtoferguson to being "about museum staff talking amongst themselves – not a bad thing, but seems tangential in some way to community engagement," are discouraging.[7] Museums can't engage communities of color before acknowledging and working through their role in marginalizing black and brown people. Furthermore, museum professionals cannot continue to cite early museologists like John Cotton Dana[8] without providing the context that Newark struggled with desegregating its public spaces.[9] While John Cotton Dana wrote about engaging all people and making collections accessible and relevant, black people were not necessarily included in this plan. Dana demonstrated progressive ideas about gender, but never explicitly advocated for race equity. This is the type of deconstruction that needs to take place before museums attempt to engage a community that they have historically turned away. Learning about the likes of Mabel Wilson,[10] in addition to Dana, makes for a more thoughtful and relevant approach to engaging black communities. #Museumsrespondtoferguson seeks to expose participants to different voices and thought processes which museums continue to ignore.

While we have logged success in inspiring museum professionals to look beyond white-centered narratives, we have not yet found the best solution for moving from conversation to action. Jumping back to the Egyptian Revolution of 2011, online participants never hesitated to take action. Action was intuitive. They believed in change and were willing to work for it. Maybe in this country racial change is not intuitive. And while Twitter can foster productive conversations, it has not fostered actions in this instance. The Charleston Massacre

unfortunately connects us to the nineteenth century motto of vigilante justice against black people. Museums can no longer view contemporary iterations of racialized violence as traumatic headlines too difficult to work through in their spaces. As organizations professing renewed commitment to community engagement, #museumsrespondtoferguson needs to materialize in gallery spaces, programming and outreach.

IMAGE CREDITS

Figure 1

Source: Black_Lives_Matter_protest,_Mall_of_America,_December_2014.jpg

Licence: https://upload.wikimedia.org/wikipedia/commons/f/fe/Black_Lives_Matter_

protest%2C_Mall_of_America%2C_December_2014.jpg

Credit: Wikimedia

Figure 2

Source: Black_Lives_Matter_protest,_Mall_of_America,_December_2014.jpg

License: https://upload.wikimedia.org/wikipedia/commons/f/fe/Black_Lives_Matter_

protest%2C_Mall_of_America%2C_December_2014.jpg

Credit: Wikimedia

NOTES

1. https://adriannerussell.wordpress.com/museumsrespondtofergusonarchive/.

2. https://firstlook.org/theintercept/2015/03/12/fbi-appeared-use-informant-track-black-lives-matter-protest/.

3. http://www.pewinternet.org/2015/01/09/social-media-update-2014/pi_2015-01-09_social-media-new_01/.

4. http://blavity.com/the-best-of-black-twitters-reactions-to-the-rachel-dolezal-naacp-ordeal/.

5. https://adriannerussell.wordpress.com/2014/12/11/joint-statement-from-museum-bloggers-colleagues-on-ferguson/.

6. Sandell, Richard and Nightingale, Eithne (Editors). Museums, Equality and Social Justice. London: Routledge, 2012.

7. http://futureofmuseums.blogspot.com/2015/03/on-morning-coffee-museum-activism.htmlhttp://futureofmuseums.blogspot.com/2015/03/on-morning-coffee-museum-activism.html.

8. http://press.uchicago.edu/ucp/books/book/distributed/N/bo16167737.html.

9. https://books.google.com/books?id=z5oWapZqV5kC&pg=PA323&lpg=PA323&dq=when+did+the+john+cotton+dana+museum+desegregate&source=bl&ots=GkOq1QAKn-&sig=TrRrtKUsxg59JYoOTascc4T6akU&hl=en&sa=X&ved=0CDgQ6AEwBGoVChMItJvU4rmBxgIViiulCh2F8wD2#v=onepage&q=when%20did%20the%20john%20cotton%20dana%20museum%20desegregate&f=false.

10. http://www.ucpress.edu/book.php?isbn=9780520268425.

CHANGE

Nick Poole

EVERYBODY LOVES a good story. We're hardwired to cheer for the hero, boo the bad guy and look for the neat resolution on the final page. It's a fundamental part of what it means to be human.

And yet life doesn't work like it does in stories. There's rarely a straight line from exposition to resolution – the girl doesn't always get the guy (or the girl for that matter).

Mike Edson's brilliant chapter, *Dark Matter*, is a story about how the world could be. He has travelled to the outer reaches of the internet and brought back tales of heroes like the Vlogbrothers and Wikipedia – born-digital brands that have achieved colossal scale at immense speed.

Why, he asks, can't our great cultural institutions – museums, libraries, galleries and archives – aspire to this same scale and speed? He urges them to don the mantle of the web in order to fulfil their cultural mission for the widest possible audience.

It's a great story, with an inspiring ending. But I wanted to use this chapter to argue for why we shouldn't be in such a hurry to get there and why we should learn to value the journey as much as the destination.

Change is a universal constant

Edson titles his essay *Dark Matter* in reference to Vera Rubin's groundbreaking discovery that in order for the cosmologists' sums to make sense our universe has to be teeming with stuff – invisible, massive and profoundly alien stuff which we depend on but never interact with directly.

All cosmological theories start with the principle that the entire universe and every single particle in it is in a constant

state of change. Fundamental laws of entropy dictate that this change tends naturally toward chaos rather than order. If left to their own devices, things will lose information content and structure instead of gaining it.

People are weird. If left to our own devices, we generally start tidying up. We create structures, catalogue things and organise them. We marshall energy and knowledge into creating things like house bricks, ice-cream, supercomputers and libraries – what David Deutsch elegantly refers to as "oases of crystalline structure in the chaos".

This makes people agents of a strange phenomenon called "emergence". Emergence is the process by which large-scale systems like life and society emerge from small-scale, rule-based processes. Anyone who has seen a fractal grow into an infinite Mandlebrot set (or a fern leaf) knows what emergence looks like.

Emergence is the process by which we swim against the tide of chaos and change – creating "oases" of order in which we can organise information and make sense of it. And I think it is the reason why every human society has always created something that serves the role of a museum.

Humans 1 Chaos 1

Whether it is the cave paintings at Lascaux, the Library of Alexandria or the British Museum, these institutions are the way we keep score in the great game between order and chaos, stability and change.

One of the funny things about emergence is that it's hard to know when you're in the middle of it. Seven billion individual agents acting rationally as they go about their lives add up to

something far greater than the sum of their parts.

There are moments when – out of the randomness of all of these processes and interactions, life forms something like a pattern. Emerging from the chaos of daily life you sometimes get a discernible movement, a big transition, a gradual transformation or a sudden revolution. These are the moments when the waveforms intersect to create something beautiful, disruptive or entirely new.

And when life forms one of these temporary, fleeting patterns which tell us fundamentally important things about all of the interactions that gave rise to them, it is the job of museums, archives and galleries to capture that moment.

Our job is not to capture every moment of every life, but to collect the objects which signify those moments when many lives came together into historically-significant stages in our collective story. History, it turns out, isn't written by the victors, but by the curator.

The moral role of museums

In his book *A Theory of Justice* the philosopher John Rawls sets out a thought experiment called the "veil of ignorance".

Broadly, the experiment asks what would happen if you hit reset on society and reverted to a position in which nobody is aware of difference on the basis of age, race, sex or nationality. In such a situation, everyone would simply be free, rational and morally-equal.

From behind this veil of ignorance, Rawls suggests that people would make decisions based on maximising the collective good, rather than their individual utility. In so doing, he points out the fundamental role that inequality and power

structures play in every part of the fabric of daily life.

Museums, libraries and archives have a stark choice when it comes to entrenched power structures. We can either call them out – highlighting their pervasive impact on equality of access and opportunity – or we can reinforce them.

Because society trusts museums to capture and preserve the moments that matter in our emergent history, this ability to reinforce power structures or to hold them to account is one of the most powerful tools that any civic institution can be given.

In her excellent TED talk, the writer Chimamanda Adichie speaks of the danger of the "single-story" that the West tells about Africa and her countries, saying:

> There is a word, an igbo word, that I think about whenever I think about the power structures of the world, and it is *nkali*. It is a noun that loosely translates as "something that is greater than another".

Adichie goes on to highlight the tremendous power of stories to strengthen the sense of *nkali* – of an inequality of narrative and representation. There is something incredibly seductive about the simple narrative, the easy-to-digest coherent explanation of what a thing is like.

And yet these simple narratives are never true – individually, institutionally, nationally or globally. Our job should never be to iron out ambiguity or expunge doubt – but to present ambiguity and doubt as morally integral elements of telling the whole, complex story.

How we use the representational tools that society hands to

museums is a matter of moral choice and professional ethics. It's why we have a 'profession', why we train people and school them in museological theory. It is also a moral imperative which we regularly fail to observe.

Web-scale platforms are amoral

This moral imperative for our heritage organisations – the duty to respect chaos, context and complexity and to use them to tell a multi-faceted story – is one critical thing that distinguishes museums from the kind of web-scale platforms which Edson cites.

YouTube is a set of software services which allow people to upload and view video content. It won't (generally) permit people to upload material that is clearly offensive or against the law, but beyond these broad constraints it is morally and thematically neutral.

YouTube doesn't have a mission to entertain, educate or elucidate. It provides the platform and invites its users to do that. It doesn't differentiate quality, but provides tools which allow trust and authority to accrue based on popularity.

The Vlogbrothers have a more directed mission, but not much more. Their interests are broad and catholic, their aim little more defined than reducing the extent to which the world sucks. That doesn't mean it isn't noble, but nor does it mean that it's a mission to which museums should aspire.

The risk is that in pursuing scale and speed as they encounter and embrace the great digital channel-shift, museums will lose not only sight of their moral and social purpose but the capacity to deliver it. We have seen this already in the past decade of large-scale digitisation programmes. How many

of these selected material for digitisation in partnership with source communities, as opposed to an internal calculus of its cultural value and portability?

We do not, in short, have the person-power to make ethical and accountable choices at scale or at speed. We need to stop and think.

Liberation and enclosure

When an object enters the possession of a public museum, archive, library or gallery, it changes state. Not physically, but fundamentally nevertheless – it becomes part of a "cultural commons".

The concept of the commons is intertwined with the idea of the internet as a centreless network. Everything, once connected to the internet, is the internet. In the same way, everything, once connected to the cultural commons, is culture.

Museums are occupied in the custodianship of this commons on behalf of society. But a commons is not inalienable – things can be removed from it as well as added to it.

Until the early 1600s, much of England was managed as common land. Using a system of open fields and shared spaces, farmers were able to use the land in common, so long as they accepted that the price of its use was a shared duty of management and care.

At the time, many believed this to be the perfect system – a symbiotic relationship in which the people who benefitted from the land were also employed in its care. In 1604, however, the first of more than 5,000 Enclosure Acts was approved by Parliament – a process by which the common lands were irrecoverably handed over to private ownership.

When a museum accepts an object into its collections, it decides whether that process is an act of enclosure or of liberation. Either the museum is taking the object out of circulation in the free market into a privileged environment to which access is constrained or it is liberating the object from private ownership for the collective good.

Whether collecting things is an act of enclosure or liberation is a question of how the museum behaves. As things stand, many museums are straddling these potential roles in a display of what I'll call "openwash". Openwash, like "greenwash" is a phenomenon whereby an institution speaks the language of openness, representativeness and diversity, but fails to make good on its words through its deeds.

Openwash is what happens when a museum claims to believe in change, but this change is peripheral rather than central, external rather than intrinsic. Examples in museums abound – institutions which view engagement and participation primarily as a marketing tool, which use conversational platforms as a broadcast medium, where the staff long to be "open" but find themselves constrained by a mission that speaks of ownership and exclusivity.

A museum does not change overnight. Becoming an open, authentic institution which performs its moral and social task consistently and professionally takes time. It is a process of experimentation and learning, risk and review. It takes three steps forward and frequently two back.

This is one of the reasons why Edson's "speed" is not necessarily right for museums. Which is not to say that change is not urgent but that there is merit in the process of changing.

The museum in a networked world

Ned Wills, former Director of the Laureus Sport for Good Foundation recently stated that "the paradigm structure of our time is the network". He goes on to explore the role of effective institutions not in creating networks but in participating in them:

> The catalyst for acceptance of sport as a true development tool, recognised for its ability to promote and sustain peace, to promote education and health and to be used as a tool for wider social development action will depend on the ability ofg the sector to coalesce and collaborate as a network.

This idea of "coalescing and collaborating as a network" is central to my vision of the future development of museums. Where now each institution is an island, entire unto itself and competing for audience and mindshare, it is my belief that we should think of all cultural institutions as part of a constellation of nodes in a network, the purpose of which is to capture those emergent moments in our shared history.

Scale for a purpose

The mission of museums is not (mostly) to commodify visitors but to deliver personal, social and educational capital for the people we interact with. It is not to engage as many people as possible peripherally with culture, but to place engagement and participation at the core of what we do and to continue to adapt our services to maximise cultural agency for our visitors.

This doesn't mean that museums shouldn't aspire to scale

– the ambition has to be to ensure that every single person feels entitled to access the cultural commons through our museums whatever their socio-economic status. But it may mean that we ought not to allow our aspirations for scale to obscure our commitment to quality, integrity and representativeness. Museums have a purpose, a social, political and moral cause. We have a duty to behave in a way that is compatible with this cause. This means taking the time to look carefully at how and why we do what we do, and to try and overcome the tendency to present singular stories and simplistic unchallenged narratives.

Embracing chaos and complexity

The opportunity, then, for museums is to take a model that has been optimised over 200 years to create the impression of order and pattern, to tell the "single stories" of historical progression and in the process to entrench power structures, and use it as the raw material for a new industry whose primary purpose is to equip everyone with the tools to engage productively and creatively with complexity.

Can we take an industry the primary output of which has been linear narrative and reverse-engineer from it a new industry that helps people deal with non-linearity?

In my view there is a need for museums to focus on what it means to step up to this fundamental role – providing a platform for people to reflect on the full chaos and complexity of our lives, not just as a project or an exhibition, but as a re-coding of the meaning of the word *museum* in the collective psyche. Can we reposition museums not as oases but as challenging places in which we can stare into the abyss and

understand change as a fundamental part of life?

My thesis in response to *Dark Matter* is that we should embrace the scale of the Web and recognise the urgency of the channel shift, but not in such a way that we lose sight of the moral obligation to represent life in the fullest, richest and most multi-faceted way we can. Let's not move so fast that we forget to challenge authority and power. In pursuing scale, let's not lose sight of what we museums really are.

REFERENCE

Rawls, John. *A Theory of Justice*. Cambridge, Harvard
University Press, 2005.

CHANGING MUSEUMS IN A PERPETUAL BETA WORLD

Janet Carding and Katy Paul-Chowdhury

WHEN I FIRST BEGAN WORK in the museum world, back in the twentieth century, the doors that marked the boundary between the public galleries and private spaces of my first museum in London had small embossed signs on them that declared, "This door to be kept closed, by order of the Director."[1] In the years since then the boundary between public and private has shifted as technology has made it possible to share the research, objects, exhibition projects and ideas that were hidden behind the closed doors. But despite the potential for new models of museum, it seems to me that for most of our users the museum is still a set of public galleries that occasionally change, and the rest remains a mystery.

Why is it so hard to change how museums work? In the last twenty-five years we've seen the rhetoric of the "new museology", the growth of audience research, and most significantly the disruption of all in its path by digital technologies. They have all moved discussions about visitor experience and user participation into the mainstream, and conferences, symposia and forums have for the last few years regularly mused with a certain amount of angst about the future of museums.[2] The TV, print media, music and publishing industries are being transformed by technological changes. And yet we still see traditional museums whenever most of us look at ourselves.

During the same quarter-century, change management has become firmly established, as in both the public and private sectors leaders look for processes that can be used to help them adapt to changing environments. But, although there have been some notable published examples, as a sector museums seem to have been slow to change.[3]

Despite the many discussions within the sector in recent

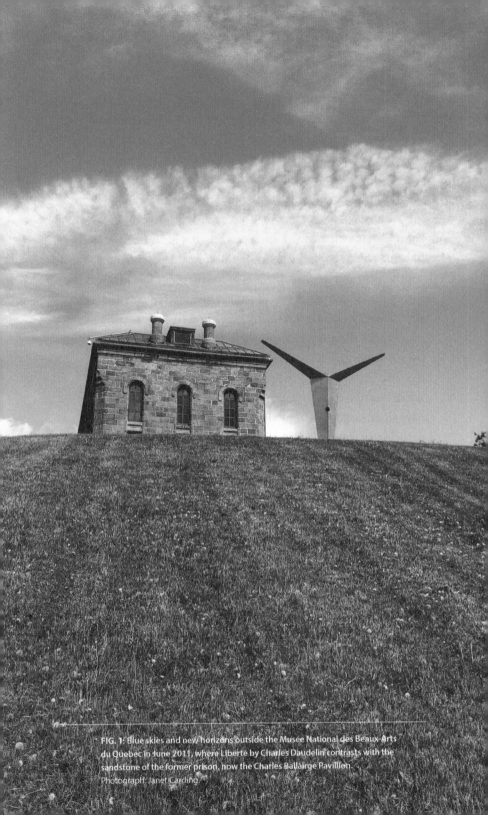

FIG. 1: Blue skies and new horizons outside the Musée National des Beaux-Arts du Québec in June 2011, where Liberté by Charles Daudelin contrasts with the sandstone of the former prison, now the Charles Baillairgé Pavillion.
Photograph: Janet Carding.

years about the need for adaptation, when I became a senior manager and later a director myself, I realized that directors tend to be under-represented at our conferences, and when they are there they don't tend to dwell on the difficult and occasionally messy work of leading museums in these uncertain times. Similarly, it seems that within the walls of museums the societal trends towards two-way participation still often become diluted when it comes to conversations about strategic thinking, funding problems, and adapting to change.

Over the last few years I've accepted invitations to speak, doing my bit to fill the gap in participation, while not claiming that I was in any way representative of museum leadership. And, as Ed Rodley was sometimes the person making the invitation, when he asked if I would contribute a piece to CODE | WORDS about leadership, strategic thinking and change I was happy to give it a go. Reading other CODE | WORDS essays, I've been struck that several of them do the hard work of imagining alternative roles and approaches for museums. I hope this chapter might be useful to some who are thinking through the practicalities of how to adapt.

My aim is to show how museums absorbed the ideas of change management popularized in the 1990s, but then to suggest that these ideas are now seriously mis-matched with the world in which we find ourselves. In particular, change that is focused on achieving a specific endpoint is out-of-step with the digital-dominated trend towards perpetual beta. I don't think we'll create museums that are appropriate for the digital age without changing our organizational cultures and how we work. Many have pointed to the need to build cultures that are focused on learning and innovation, and as educational

institutions one might expect museums to be leaders in this area, and yet it seems hard to find examples. During my tenure as Director and CEO of the Royal Ontario Museum (ROM) in Toronto we undertook a number of professional development initiatives to build our capacity to innovate and adapt, and I have invited Katy Paul-Chowdhury, who worked with us to develop the process, to write about one of them in an appendix to this chapter. My sense is that as the leader in museums I need to be focusing as much on ensuring we have the appropriate organizational culture, as on any other part of our strategy. While I don't have a set of easy answers about how this can be readily achieved (I wish I did)[4] the last part of this essay is devoted to the sort of thinking and processes that could point the way.

How we have talked about strategy

Strategic thinking for a museum has typically been encapsulated in the strategic plan, a document spanning several years which communicates a summary of the main priorities.[5] It is used with funders, in community discussions, is sometimes a pre-requisite for grants or accreditation, and inside the building is often the starting point for departmental and individual plans for the year ahead.[6]

A strategic plan may well be very practical in specifying projects and measures, but can range across big philosophical areas of contention such as:

- The purpose – what is the museum for?
- The users – who is the museum for?
- The experience and activities – how to meet users' needs

and ensure the museum is relevant?
- The collections – what role do they play?
- The funding – how best to fund the museum and ensure it is sustainable in the longer term?
- The changing staff, structure and skills – who does what, and how are they organized?

These areas are of course interwoven, and so change in one area should mean change in others too. When it comes to creating a new strategy for a museum, it is going to mean changes in all these areas, so it is important to deal with the complexity of them all rather than assume they can each be addressed in isolation. At the same time, making change in one area won't necessarily bring about change in others. While they often begin with a vision of the future museum, strategic plans often focus on the tangible changes – the new galleries or facilities – with the assumption that changing the visible will also automatically change the way staff work.

This focus on the tangible occurs because the strategic statements from the Director and the written plans are often tailored to those whose support they need to embark on a new direction, the Board, funders, potential donors and community stakeholders. With good reason they are written for an audience beyond the museum's staff and users, describing new plans for what the museum does which will be attractive to funders, and linking them to persuasive comments about the museum's role in the community. This story must rightly be simple, powerful and externally-focused to galvanize support. But to deliver successfully on a new strategic direction also requires accompanying change inside the museum in the

behaviour, priorities and processes used by the staff and volunteers. *Doing something new rather than doing the same thing in a new building means also learning how to work differently.*

As the external face of the organization and spokesperson for the plans, in the past, the leader was seen as akin to a military strategist who mapped out a plan for the organization, which he (or occasionally she) then implemented by directing those around him. But if that was the case in the distant past, as change management techniques became common in the public and private sectors, the lone strategist narrative has been revealed as often inaccurate or ineffective. Newer approaches to strategy have emphasized more collaboration, as well as more iterative processes which blur the traditional distinctions between strategy formulation and implementation.[7] These more modern tools and concepts have been increasingly used in the museum sector. Typically, creating the family of vision, mission, goals and measures that often make up a strategic plan has been the first step in making change, and so the methods used to create that plan have been drawn from change theory.

In the 1990s, influential management theorist John Kotter (1995) described a flowchart of the "eight steps to transforming your organization" that described a method and language of change.[8] While originating in the private sector, Kotter's method could be used in museums and had the benefit of being understood by that decade's increasingly business-focused boards and funders. The first steps set out the need to create a sense of urgency for change, and to assemble a group with the power to lead the process, followed by creating a vision and strategies to achieve that vision, which is communicated

to the staff, and then implemented.

I suspect that for many museum professionals who find themselves in management roles, this sequence feels very familiar and embodies much of what strategic leadership is thought to involve, assembling a team which develops a shared vision, followed by putting it into practice. This language of strategic planning, visioning and change has become common and creates documents that are used as guides for the changes to be made.

While Kotter's flowchart can still be useful as a guide to change, in these uncertain and rapidly-changing times there seems to me something rather quaint about so deterministic a process, where the leaders at the top of the organization have the new ideas, and who alone are charged with coming up with a new vision. It is true that in recent years strategic planning has often become more participatory,[9] with cross-sections of staff involved in visioning workshops, and project teams set up to support implementation, but even so *the idea that there is an endpoint to the change, a desired future state that can be achieved after which everyone goes back to their day-jobs seems increasingly old-fashioned.* Some commentators on Kotter's approach (such as Ashkenas, 2015) have pointed out that change is not finite and then institutionalized, but much more continuous, and have encouraged more experimental, collaborative approaches at every stage.[10]

When looking at museums, my personal feeling is that they are so intensely heterogenous, with many different types of expertise and specialism, that new thinking must come from all parts of the organization, and from involving your users as part of the process, and not just draw on the senior

management team. So agendas for change which come only from the leader will be missing the most significant potential innovations. But, just as importantly, continuing to see strategic change in museums as having a defined endpoint can further encourage planning which focuses on visible differences, and underplays the change in the way the museum and its staff operate.

Strategic planning has not led to strategic re-invention

In recent years there have been many examples of new buildings, new galleries and capital campaigns which have come from strategic plans put together using these sort of methods, and yet apart from a small number of notable exceptions it feels as though the results look rather like similar to what was built before the advent of the smartphone and internet. A couple of examples from CODE | WORDS are illuminating in this respect.

In his polemical chapter, *Dark Matter*, Michael Edson speaks of the digital changes that museums have made, but then muses that museums have been focusing on only a small part of what the internet can offer, and missing the 90% akin to the universe's dark matter. I love this essay but I can't help but feel that even then he is being rather too optimistic about what has been achieved, having just come back from yet another museum conference where much of the conversation was about how we can make our collections accessible online – a full generation after this first became possible. In many cases strategic planning has failed to help museums make a fundamental shift in their practice.

Bridget McKenzie, in her chapter *Towards the Sociocratic*

Museum, describes a sociocratic governance model as "non-hierarchical, consent-based and rooted in its communities" with audiences that are, "citizens and collaborators". For the majority of museums that she conceptualizes as plutocratic or bureaucratic models, established by rulers or as public services, a radical re-invention is needed that favours "the unpredictable outcomes of creative practice, and the sustainability of heritage, ecology and diversity." A powerful call to action, but I fear such re-invention is unlikely to come about through putting the museum's management team in a room and refusing to allow them out until they have the first draft of the new strategic plan.

It is worth noting that 100 years ago we had galleries, displayed objects, and held lectures, much the same as now. Despite all the discussion about the need for change in museums, it has been minimal when compared to that in print media, or the music industry.

How then do we change the way we work both to make the museum more porous to new thinking from outside its walls, and also build the skills and confidence to work with our users as collaborators? While setting a strategic direction can still be a good framework for talking to ourselves and others about the future, *to re-invent museums we must also create a culture that is biased towards doing new things rather than towards the past.* By creating such a culture of innovation we will build the capacity for change, resilience and working with others. Such a culture would also be supported by processes, organization and skills that align and reinforce that bias towards the new. For instance a change process in a museum with such a culture might be more experimental, more iterative and more collaborative.[11]

Professional development that can produce this sort of cultural change would need to be intentional, practical and be closely linked to priorities. In 2014, at the ROM we tried such an approach, working with Katy Paul-Chowdhury in our centennial year to build a professional development program called *100 Day Change* that asked teams to deliver initiatives which were part of our current strategic plan, but also encouraged them to build their skills in problem-solving, innovating and leading change. You can read Katy's detailed account of the program as an appendix to this chapter.

This program provided practical training on how to lead change to a diverse cross-section of ROM managers, as well as providing a tool-kit they can use again and again. It also shifted our approach to strategy and strategic-level change in some significant ways.

First, instead of observing a linear "formulation to implementation" process, we introduced more iteration, experimentation and learning. Stepping inside some major strategic decisions, these projects were used to help change and sharpen the strategies, and inform how they should be carried out. They provided input into gallery strategy, digital strategy, and audience engagement.

Second, the training program made our strategic thinking more collaborative and interactive. The projects, and the teams' regular reports to sponsors and the ROM executive, gave voice to the experiences and insights of managers who were not previously engaged in the ROM's strategy development process. Because the teams combined people who did not normally work together, they also allowed different types of strategic insights to be generated. And each project also

brought the experiences and feedback from ROM visitors and stakeholders into the mix in a systematic way.

I feel that putting this kind of focus on staff throughout the museum, gaining the skills to lead change, and having a bias towards the new, enables museums to move away from a "too busy to do it differently" approach. But it starts from where museums are now, complete with hierarchies, history and sometimes cumbersome processes, and begins to shift the way strategy is developed, and people involved, including our users. The learning can be taken into the projects that follow, and the thinking into the next strategy sessions.

Changing museum culture

The culture in museums does seem to be particularly consistent, so it is worth considering whether there is something about museums that makes them uniquely hard to change? When I asked Katy she thought not. "Change", she said, "is always a challenge." But she thought that change in museums is characterized by:

> ...significant resource constraints, together with the limitations and opportunities imposed by a public mandate, multiple stakeholders, many more specialized subject matter experts than professional managers, access to a committed base of volunteers, and an inherent bias that looks back not forward. [12]

Phew! This is my sense too, and in particular that despite the pressing need for radical re-invention we nevertheless all sometimes feel that as we have too much to do, we are too busy

to do it differently. Even so, I've been surprised at how often museum professionals settle for a reality that is explicitly at odds with their preferred approach: I regularly hear about teams developing exhibitions without any user involvement in prototyping, despite years of research in evaluation, and the many conference presentations that have shown its value.

With their purpose to preserve the past, museums do tend to reverse into the future, with a powerful sense of authority and history that I suspect makes the creation of a culture biased towards innovation much harder. Museums also have entrenched hierarchies, silos of different professional groups, and systems that might have been there since our founding – our current mindsets can create a powerful inertia that is hard to overcome.

So, how do we turn and look towards the future, equipped as best we can be to adapt to changes that are happening quickly and without precedent? *By establishing that it is the role of the museum's leadership to build the teams, processes and skills that together create the capacity for change.* Museum leaders can become their organization's facilitators-in-chief. They can encourage their staff's capacity for new thinking and problem-solving through doing, by setting up opportunities for leading change across the museum. By bringing together teams and coaching them, the museum's leaders can also see new initiatives implemented quickly.

Making the kind of approach we trialled at the ROM part of the mainstream way of working requires constant support, encouragement and attention, in order to prevent inertia and the bias towards the past resurrecting itself. Of course this particular method is not the only one, and much is being written

at present about agile management and design thinking, both of which focus on iteration and experimentation, but *the commitment of the leaders to invest in re-inventing the organizational culture is key*. Rather than leading static museums, we should be creating adaptable museums.

Alongside learning through doing, leaders can also encourage and prioritize looking outside the museum walls for new information, trends and inspiration which can be brought into discussions. It seems strange to say in this connected age, but our museums can still be very inward-looking. Social media and the internet enable us all to take charge of our own professional development and be life-long learners, but role models and encouragement help. Supporting a bias towards the new, together with talking, listening and co-creating with visitors reinforces an emphasis on relevance.

Museum leaders should also explore different approaches for establishing strategies and choosing priorities. Moving towards a strategic framework about *what* impact the museum is aiming to achieve first, and *how* it plans to achieve it second will serve to rebalance the conversation between new buildings, online engagement, and new ways of working for the staff. For example, over the last ten years, logic models and the theory of change[13] processes which originated in international development and social enterprise have begun to be used by museums and offer some alternative options for strategic planning.[14] They place emphasis on impact and outcomes, and often include community engagement as integral steps. The Digital Engagement Framework[15] developed by Jasper Visser and Jim Richardson also emphasises the creation of value, and includes co-creation with users, and organisational transformation.

Choosing how to develop strategy, agreeing measures of impact and seeing strategic thinking as the beginning of organisational learning and transformation is an important part of museum leadership, and I suggest still sits with the Director as s/he will be held accountable for the museum's progress by the board and funders. *But choosing an approach which builds a culture of innovation as you go, and establishes the idea of innovating to deliver agreed results, increases the chances of seeing significant change which makes the museum more relevant, and creates more leaders along the way.* Setting targets and encouraging experimentation may sounds like opposite approaches, but by keeping the focus on *what* outcome is to be achieved, and allowing a project team to work out together *how* they achieve it, the two can be aligned.

Museum leaders also have an important role in telling the story of the museum within the community. A vision or strategic plan created by a museum team with a culture of innovation would be informed as much by emerging ideas or experiments from the team, as by a direction set from the top, but there is still a need to synthesize it into a compelling narrative for stakeholders, and as well to ensure it is relevant and makes sense as a whole. Museums are having to work harder to secure the funds needed to deliver their plans, and there are no guarantees that those who have supported in the past will do so in the future, particularly in these times of austerity in many parts of the world. Museum directors spend a good proportion of their time fund-raising and working with the community, and securing resources will continue to be a major part of any leader's role (which is another reason to create more of them).

I see us moving into an era where museums start to look

much more like the works-in-progress that they actually always have been when we look at the whole museum, not just the public spaces. Places where – taking the lead from the online world – we make a virtue of museums being in perpetual beta, rather than striving to create timeless galleries of unchanging artworks and artefacts. The door between the public and the private is no longer always kept closed, and involving our visitors can become one of the ways we bring our museums to life.

But as we let go of the concept of the static museum, we must also let go of the idea that as museum professionals we will have the same jobs in the future as we have in the past. We've all (I hope) experienced the energy that comes from galvanizing around a new project; the passion and excitement of visualizing something new and then creating it for real. The challenge is how as leaders and managers we make that the way we work and feel all the time.

FIG. 2: A pedestrian passes the Michael Lee-Chin Crystal of the Royal Ontario Museum in March 2015. Photograph: Janet Carding.

APPENDIX

Case study: 100 day change at the ROM
Katy Paul-Chowdhury, The Change Agency

The ROM was in transition, with managers at all levels working to enact a new strategy, and make the cultural and behavioral changes required to make it a success. Many came from specialized academic, technical and functional backgrounds, and few had formal training in leading change.

Based on ROM decision makers' and my own experience, and echoed in management education literature, the best way to learn how to drive change is to *do it*. That way, training inputs are applied immediately, and managers can receive practical support as they navigate the complexities of making change in their organization.

Training program structure
To ensure that managers were learning to drive change in ways that fit with the larger cultural shifts underway, the training program had to be: results-focused, rapid-cycle, innovative, experimental and collaborative. These principles underpinned the design.[16]

The program had two main elements: actual participation in one of three results-focused, 100-day change projects; and monthly three-hour reflection and skill-building sessions. It was designed to blend change theory, practical tools, actual experience, and real-time coaching – with emphasis on the actual experience. The process ran like this:

- ROM leaders identified strategically important areas in which they needed to see real change quickly. Three were identified for projects. A member of the ROM executive agreed to sponsor each of three teams, providing senior-level support and guidance.
- In a facilitated launch session, each team agreed on a measurable "stretch goal", to be achieved in 100 days. Each goal represented real progress against a major change priority in the ROM, and would also provide valuable learning about how to move forward.

The 100-day results goals

1. Build ongoing relationships – and keep the ROM relevant – through increasing use of interactive, participatory, experience-rich museum practices. Measured by engaging 25% of daily visitors to the Asian galleries in a participatory activation that will inform content and delivery in the future.

2. Improve visitors' experience by helping them make informed decisions about which events and offerings include in their visits. Measured by improving the reported onsite visitor awareness of permanent and temporary offerings relevant to them by 50%.

3. Begin digitizing the museum's extraordinary collections to expand audience engagement, access, and convenience. Measured by developing an interactive web interface to be piloted on the ROM Learning Portal organized by the Centres of Discovery and tested by a focus group.

During implementation, teams employed the disciplines of

clear work planning, weekly team meetings, and periodic check-ins with their Sponsor. Each team also had access to a facilitator, as needed.

The whole training group also met three times during the implementation period, so they could update each other on their progress, reflect on what they were learning about driving change, and receive targeted training input. Topics covered included project management, communications, and a range of ROM-specific content.

Everyone also met with the Sponsors for 30-day, 60-day, and final project reviews. There, they reported on their progress and learning, and made recommendations for sustaining and building on the results achieved.

Results and learning

All three teams showed impressive achievements. For example, the team which piloted participatory practices tested three low-effort, high-impact activations in the museum's extensive but under-visited Asian galleries. The activations were chosen to appeal to a variety of visitors and learning styles:

- A "scavenger hunt", where visitors had to find specific items in the collection, and link them to descriptors (e.g., beautiful, important, familiar).
- A regular "meditation" period, featuring appropriate music and dimmed lights in an area populated by awe-inspiring religious paintings and statues.
- Interaction with volunteers and artifacts around the traditional tea ceremony.
- The team further empowered visitors of all ages to explore

and understand the collection through the deployment of maps and knowledgeable volunteers.

By making these changes time-bound and experimental, the team cut through months of proposals, approvals, and bureaucracy. They learned what it really took to make these changes – from who needed to be involved to how to manage the lighting system. And their findings challenged several widespread assumptions about making museums more interactive, including: the requirement for it to be hi-tech, and the separation of adult and family (children's) interests. Other findings about increasing interactivity in the museum's galleries included:

- Our audience, in general, likes interacting with REAL people.
- Volunteers are an energy-rich, engaging and valuable source.
- Activating a space doesn't require a lot of staff time or money, but if prep is done well, and volunteers are incented and rewarded, then it is sustainable.

The team also far surpassed their results goal, engaging between 28% and 45% of visitors to the Asian galleries during the activation periods. They increased the number of first-time visitors to the galleries from 57% to 63%, and the number of families with children from 19% to 40%. Visitors reporting a stand-out experience increased from 63% to 77%.

The team which focused on visitor awareness of each day's offerings piloted the use of a sign, a kiosk, and an information desk in the museum's large entry hall, and tracked visitor use

and feedback for each experiment. Understanding the effectiveness of each, and visitors' preferences for planning their visits, provided valuable "real" input to a major structural redesign of this welcome space, planned to begin the following year. Innovations reported by the team included:

- The entire project was experimental in nature, aimed at trying out ideas and learning from them, rather than creating the perfect solution on the first try.
- It was the first time that a museum-wide directory was available on the floor as part of the entry/orientation experience.
- The kiosk included all the events which occurred on any given day – including the GI and Scopify App tour, as well as the tours and special exhibitions.
- The kiosk was cross-linked to the website, which eliminated the need for daily updates on multiple platforms.
- We printed graphics in house, and taped them on the wall. This was in keeping with the deliberately experimental approach, and represented a major cultural change for an organization that always wants visitors to see polish and perfection.

The goal as it was originally stated proved impossible to actually measure, a point of learning about how to structure results goals for maximum impact. But the team was able to track audience reactions and feedback which would be important to the larger project's design. For example:

- A majority noticed/used the sign, and 96% of respondents

stated it was "very" or "somewhat" helpful.

- The sign helped 90% of adult visitors identify galleries relevant to them, and 100% of visitors with children.
- Only half the respondents noticed the kiosk, and 26% used it.
- Those who used the kiosk felt it was "somewhat helpful" (75%).

More generally, the team learned that visitors want a simple and direct information on What to Find Here. Visitors were excited about having a directory and an information desk. In particular, personal interaction with the staffed information desk was very popular. Visitors were more receptive to the ROM offerings organized by floor, rather than by Centres of Discovery (a more thematic approach to grouping offerings, central to the museum's strategy).[17] And the informality of the less polished signage and information desk seemed to engage visitors, not turn them off.

The team which focused on digitizing collections was able to develop and test a beautiful prototype interactive web interface, organized around the museum's Centres of Discovery. They went on to distribute a survey to 1,000 teachers asking for feedback on the site.

This project also provided immediate value, while generating real learning that would be reflected in the major planned investment to digitize the museum's collections. Lessons, which are expected to increase the success and streamline the costs of the digitization effort, included:

- Takes a coordinated effort, from what and how data is

recorded in the Content Management System (CMS) to which fields/content is of interest to visitors to how to present the content in an engaging, interactive way online.

· This coordinated effort requires us to work across different departments in a fully integrated way.

· Visitor feedback is vital as it will help to inform what data from CMS needs to be pulled for the web interface and how the data is presented to the public.

· From the user's perspective, content and functionality are inextricably linked – we cannot focus on one without the other.

While all the projects involved collaboration across functional lines, and between internal and external stakeholders, this one perhaps required the most. Team members had to engage many different curators, interpretive staff, media and design groups, technology, and the important audience of teachers.

In terms of leading change in the ROM more generally, participants reported rich learning related to four areas of their work

The value of a sharp results goal and 100-day timeline

· "Rapid results goal is focused yet allows for creativity and flexibility."

· "We had to prioritize work load and say "no" to things that didn't align with expectations and resources to achieve the goal."

· "Don't try to do all at once – set bite-sized and achievable goal"

- "Need specific timeline with a strict/enforced deadline to keep focused and to prioritize work load"

How they worked together

- "Building wide coordination and consultation is required for all projects."
- "Change requires team work and working together quickly. Be ready to take responsibility and assist in breaking down large tasks to small assignments. "
- "Create diverse, cross-departmental teams that are empowered to make decisions and move action forward."
- "Teamwork, communication, and willingness to take on different types of work needed by all involved."

Roles and resources

- "The opportunity to be involved in creative development of a project requires different ways of thinking for team members."
- "Leverage existing projects and content to secure funding, staffing, and don't "reinvent the wheel"."
- "Senior Management support of this project made it a priority so that execution was facilitated."
- "Staff that are tasked with driving or participating in this type of project should have designated time in their normal work load to fully engage and be more innovative as a result."

ROM processes, practices and culture

- "Streamlining of approval process allowed us to get work done."

- "We can't be afraid to fail! Let's learn from it!"
- "Need to trust and give freedom to the team to take full ownership of their project."
- "An open-mind & willingness to try new things (and not rely on "We've always done it this way…")."

It would be a mistake to imagine that the process was easy. The teams struggled mightily with competing demands on their time, accessing the people they needed without disrupting other priorities, and the challenges of driving change in a very resource-constrained environment. But even with these challenges, the ROM managers:

- Learned how to structure, launch, and drive a high-impact change initiative.
- Gained real experience making this kind of rapid, targeted change in the ROM.
- Reflected on their experiences in structured ways, translating them in to deeper learning.
- Developed a cohort of peers they can partner with to follow this process again, more easily, themselves.
- Achieved real results, in areas strategically important to the ROM, in 100 days.
- Accelerated the process of cultural change in the ROM, toward more collaborative, flexible, experimental, rapid-cycle work and mindsets.

ACKNOWLEDGEMENTS

My thanks to everyone involved in the project at the ROM, and particularly to Dr Katy Paul-Chowdhury. Thank you also to Xerxes Mazda who read an earlier version of this essay.

My special thanks to Ed Rodley for having a wonderful combination of traits – the patience of a saint, and the herding abilities of a shepherd.

NOTES

1. For this chapter I am defining "museum" as including, art galleries and other similar cultural organizations

2. See for example the online Future of Museums Conference held in July 2014. Information retrieved from http://futureofmuseums.com/page/welcome-information; the symposium held in May 2015 on "The Future of Museums and Participation" by the Asia European Museum Network at the National Folk Museum, Seoul, Korea. Information retrieved from http://asemus.museum/event/international-symposium-the-future-of-museums-and-participation-korea/; and the Centre for the Future of Museums established by the American Alliance of Museums with its many resources and discussions. Information retrieved from http://www.aam-us.org/resources/center-for-the-future-of-museums.

3. See for example Fleming, D (2005, Nov 8) Managing Change in Museums – Keynote Address INTERCOM conference, Prague. Retrieved from http://www.intercom.museum/conferences/2005/.
 See also Suchy, S (2003) *Leading with Passion: Change Management in the 21st Century Museum*, AltaMira Press; and Janes, R (2013) *Museums and the Paradox of Change* (3rd Edition), Routledge.

4. As at time of writing (Sept 2015) we're working on a new strategic plan for TMAG.

5. My feeling is that when we do talk about strategy and change as leaders we all too easily slip into management speak full of missions, burning platforms, and

resistance. These words all seem so clichéd, so I've tried to write this piece while avoiding Don Watson's weasel words, in the hope that this will lead to a more clear and informative description. (See Don Watson's writing that calls out management-speak, particularly Watson, D (2004) *Dictionary of Weasel Words*, Random House; and Watson, D (2009) *Bendable Learnings: The Wisdom of Modern Management*, Random House. But I recognise I am running the risk that it might just make everything sound more dull!

6. See for instance Victoria and Albert Museum (2014) *2014–2015 iteration of the 2011–2015 strategic plan*, UK London. Retrieved from http://www.vam. ac.uk/__data/assets/pdf_file/0006/240576/14-15-Iteration-of-the-Strategic-Plan1. pdf and Museum Victoria (2013), *Strategic plan 2013–18*. Retrieved from http://museumvictoria.com.au/pages/1711/mv_strategic_plan_2013-18.pdf.
 The Museum of Modern Art, New York has a mission statement with goals that covers similar territory: Museum of Modern Art, *Mission Statement*. Retrieved on 20 September 2015 at http://www.moma.org/about/index.

7. For a survey of approaches to strategic planning see Mintzberg, H, Lampel, J, and Ahlstrand, B (1998) *Strategy Safari: The complete guide through the wilds of strategic management*. USA, Free Press.

8. Kotter, J (1995) "Leading Change: Why Transformation Efforts Fail." *Harvard Business Review* (March-April 1995: 59-67). Retrieved from https://hbr.org/2007/01/leading-change-why-transformation-efforts-fail. A 2007 reprint of the 1995 article.

9. Kotter has modified the flowchart over the years to become more participatory, see the current version from Kotter International retrieved on 20 September 2015 at http://www.kotterinternational.com/the-8-step-process-for-leading-change/.

10. Ashkenas, R (2015) "We Still Don't Know the Difference Between Change and Transformation", *Harvard Business Review* (January 2015) Retrieved from https://hbr.org/2015/01/we-still-dont-know-the-difference-between-change-and-transformation#.

11. Ed Rodley has written about the prerequisites for embracing new ways. See Rodley, E (2012, Feb 19) "Vision, Desire, Attitude and Focus". Posted to *Thinking about*

Museums at https://exhibitdev.wordpress.com/2012/02/19/vision-desire-attitude-and-focus/.

12. Paul-Chowdhury, K (2015) personal communication.

13. For a history and review of the use of Theory of Change see Anderson, A (2004, Oct) *Theory of Change as a Tool for Strategic Planning. A Report on Early Experiences.* USA, Aspen Institute Roundtable on Community Change. Retrieved from http://www.theoryofchange.org/pdf/tocll_final4.pdf.

14. The W K Kellogg foundation created a guide for non-profits in the use of logic models. W K Kellogg Foundation (2006, Feb2) *W K Kellogg Foundation Logic Model Development Guide.* Downloaded on 20 September 2015 from http://www.wkkf.org/resource-directory/resource/2007/07/spark-theory-of-change.

Nina Simon and her staff have recently used the Theory of Change approach. See Santa Cruz Museum of Art and History (2015) MAH Theory of Change retrieved 20 September 2015 from http://www.santacruzmah.org/about/mission-and-impact/ and Simon, N (2015, March 25) "Developing a Theory of Change, Part 1: A Logical Process", posted to *Museum 2.0* blog at http://museumtwo.blogspot.com.au/2015/03/developing-theory-of-change-part-1.html.

15. Visser, J and Richardson, J (2015, Version 3) Digital Engagement Framework. Retrieved 20 September 2015 from http://digitalengagementframework.com/.

16. This training was based on Schaffer Consulting's rapid results methodology.

17. http://www.rom.on.ca/collections/.

FURTHER READING ON CHANGE AND LEADERSHIP

Leadership development

De Smet, A., Lavoie, J., and Schwartz Hioe, E. (2012). Developing Better Change Leaders. *McKinsey Quarterly*, April 2012. Retrieved from http://www.mckinsey.com/insights/organization/developing_better_change_leaders.

Gurdjian, P., Halbeisen, T., and Lane, K. (2014). Why Leadership-Development Programs Fail. *McKinsey Quarterly*, January 2014. Retrieved from http://www.mckinsey.com/insights/leading_in_the_21st_century/why_leadership-development_programs_fail.

DeSmet, A., McGurk, M., and Schwartz, E. (2010). Getting More From Your Training Programs. *McKinsey Quarterly*, October 2010. Retrieved from http://www.mckinsey.com/insights/organization/getting_more_from_your_training_programs.

Leading organizational change

Schaffer, R. H., & Thomson, H. A. (1992). Successful Change Programs Begin with Results. *Harvard Business Review*, 70(1), 80-89. Retrieved from https://hbr.org/1992/01/successful-change-programs-begin-with-results.

Matta, N. E., & Ashkenas, R. N. (2003). Why Good Projects Fail Anyway. *Harvard Business Review*, 81(9), 109-114. Retrieved from https://hbr.org/2003/09/why-good-projects-fail-anyway.

A PLACE FOR EVERYTHING: MUSEUM COLLECTIONS, TECHNOLOGY AND THE POWER OF PLACE

John Russick

"EVERYTHING CAME from someplace." That's what my eleven-year-old son said to me when I told him about my latest project. I was talking about the *Chicago 0,0* app prototype we are developing at the Chicago History Museum (CHM). The app's name comes from the downtown intersection of State and Madison Streets, where the city's street numbers begin at zero. I told him that we were hoping to use Chicago's street grid to push some of our collection out of the museum and share it with people in those same locations today. As the son of a museum curator, he's been going to, walking through, and thinking about museums all his life. More importantly, he's being raised in twenty-first century urban America, so he's been schooled in and through technology. And he understands that many, many people have called this place home over the past two centuries and that evidence of their time here is often still visible if you know where and how to look. It wasn't hard for him to see beyond the immediate goals of the project.

My plan was simple: bring historical images of Chicago into the city's central business district via an augmented reality (AR) mobile app. As a way to get started, I was searching the collection to find photographs taken at or near the corner of State and Madison which had been or could be digitized. The challenge was to find images that included buildings or infrastructural elements which I could use to align the image from the past with the site today, effectively bridging the gap between the place that was and the place that is. My son understood the idea immediately, but he wondered if all the museum's images could be placed. Since the collection is all about Chicago, wouldn't it be logical to think that all the photographs we have come from places that are still here?

"Everything came from someplace," he said. I told him that, for the most part, he was right. But it took a bit of time for that idea to sink in (to my brain).

When I was first approached to write something for the CODE | WORDS project, I had the idea to write a tongue-in-cheek piece about the museum world from the perspective of the Rip Van Winkle Curator of All Things Olde who emerges from object storage to discover that a technological revolution has occurred while he was working in the collection. He doesn't recognize the museum. It's loud and boisterous, packed with kids and families sharing their ideas and moving through galleries filled with interactive experiences designed to make the visit more meaningful and fun. Overwhelmed and uncomfortable, he retreats to the safety of his collection, certain that he has no role in this new environment.

Like the character from Washington Irving's story who goes to sleep before the American Revolution and wakes afterward to find that everything has changed, I found the idea of the curator struggling to find a role for himself and the collection in an increasingly technology-driven society compelling for a piece meant to explore the changing nature of the museum enterprise in the digital age.

The problem with that essay is that it would have been constructed on a false character. The curator, clinging to his precious collection, unable and unwilling to share it with anyone not blessed with the impulse for contemplative study or the natural insight to see the deeper meaning of objects, is a straw man. He may exist in some form somewhere, but the image of the museum professional so set in his ways, so aloof and cold that he shields his collection from people like a miser is, for

the most part, an anachronism.

The truth is that, at worst, today's curators are more like Scrooge on Christmas Day than Rip Van Winkle. We may have only recently awoken to the potential positive effects of technology on our work, but we are increasingly ready to engage with these tools. And we don't want to waste any more time working in a way that fails to meet people where they are. We may not be technophiles, but we aren't necessarily technophobes either. We can easily see that technology has made our rolodex obsolete, the phone on our desk too limiting, our camera too time-consuming, and the museum's card catalog, literally and figuratively, out of date. And those are just the things we notice without really looking. On closer inspection, we realize that our visitors are all thinking and learning and sharing and socializing and seeking information and experiences in ways that have turned the traditional model of the museum visit on its ear.

Many of us invested in informal object-based learning are wondering how collections fit into this new reality. What is the role of the artifact when learning increasingly occurs in a digital form? More fundamentally, is it our job to make our collections compelling? Or are our collections just tools for us to use to help people learn, share, and understand the subject to which our museums are dedicated? If we can't make objects compelling, perhaps we don't need to use them. But if we don't or can't use them, perhaps they have no role in the twenty-first century museum?

In fact, in a 2011 article published in *History News*, the magazine of the American Association for State and Local History, independent curator Rainey Tisdale posed the question,

FIG. 1: Image generated by the *Chicago 0,0* prototype app near the corner of Madison and State Streets in Chicago, featuring a digitized historical photograph of two men looking for work during the Great Depression. Photograph: Chicago History Museum & Geoffrey Alan Rhodes.

"Do history museums still need objects?"[1] As is often the case with provocative rhetorical leads, the ensuing paragraphs do not upset the proverbial applecart. But it's worth pointing out that although Ms. Tisdale ultimately confirms the value of artifacts, using statements such as, "We need objects more than ever," she also qualifies her support. She suggests that we only need objects if "we do something great with them" and that we may need objects but "we may not need the ones we've collected."

Tisdale's challenge to do something great can be daunting. For most of us there is a firewall around our objects: protective glass, rope barriers, alarms, and security personnel (and that's just for the objects on display). How can we push the envelope when preservation nearly always trumps access in our policies and our behaviors? This is where the ongoing expansion and development of digital tools in our museums and communities can help us. We can experiment in this realm. We can iterate. Test an idea, develop an experience, evaluate it, and decide if it works. If it does, we can do more. If not, we can try something new more quickly and easily than ever before. Today, the technologically proficient museum can be a laboratory for engagement as we think and rethink how to break down the barriers to access and share all that we have with anyone anywhere.

For example, AR apps are not new, but so far museum AR apps have been mostly limited to featuring visual imagery from the collection. The central characteristic of these experiences is a simultaneous then-and-now view of a place constructed from a live image with an overlay of a painting, drawing, photograph, or postcard (Figures 1-4). More recently, museums, including the Andy Warhol Museum and the Museum of

FIG. 2: Image generated by the *Chicago 0,0* prototype app near the corner of Randolph and State Streets in Chicago, featuring a digitized historical photograph of a Walgreens store. Photograph: Chicago History Museum & Geoffrey Alan Rhodes.

London, have developed AR apps promoting their collections by placing historical AR experiences at specific contemporary locations. But what I find most intriguing about the *Chicago 0,0* app is the long-term implication of geo-locating all the objects, images, and documents in our collection.

Ultimately, every CHM collection item has a place or places associated with it. A suit of clothes could be mapped to where it was made, purchased, tailored, worn, even collected. A letter could be assigned locations according to where it was written, where it was received, the home of the person who wrote it, and the places they wrote about. Once created, the app could transform the current urban landscape into an historical excavation of the people and places that have defined Chicago over time. It could provide CHM with a new tool for sharing the city's stories and help us connect the museum to the diverse audiences we hope to reach across the urban landscape.

While this would be an amazing and powerful tool for understanding the city's history, if we reframe the museum's collection in geo-spatial terms, what else might be revealed? What might we discover about our collecting priorities over time? I suspect that the vast shortcomings of our collection will be laid bare. We would clearly see the underrepresented neighborhoods, unheralded stories, and undocumented events in the lives of people and communities that didn't matter to us at the time. These deficiencies would appear like black holes on a map of space, areas shockingly devoid of documentation during certain time periods or between one street and another throughout the city's history.

CHM's collection is supposed to be a tool for understanding the city, but perhaps it is primarily a tool for understanding the

FIG. 3: Image generated by the *Chicago 0,0* prototype app near the corner of Washington and State Streets in Chicago. Photograph: Chicago History Museum & Geoffrey Alan Rhodes.

FIG. 4: Image generated by the *Chicago 0,0* prototype app near the corner of Madison and State Streets in Chicago featuring a digitized historical photograph of a crowd and police officer at the entry to Louis Sullivan's Schlesinger and Mayer store. Photograph: Chicago History Museum & Geoffrey Alan Rhodes.

museum. Our idiosyncratic collecting history would likely be revealed as racist, sexist, and driven by the ideals and lifestyles of the privileged class. But what if we shared that map with everyone? What if the entire city could see what is and what is not in the museum? What if they could fill in the missing parts? Could we both confront our nineteenth- and twentieth-century ideas of inclusion and representation and begin to rectify the shortcomings of that limited vision?

I suppose it's possible that my predecessors wondered what the CHM collection might look like if presented on a 4D map of the city (time being the fourth dimension). But with millions of items in our care, they could not have created such a map, and it certainly could not have been shared with the public, or manipulated by them, or used as a tool for evaluating our collecting habits over time. Technology makes it possible for us to ask and answer questions that could reshape the way we work. However, it's not enough to note that the technology could make a collection map possible. The reality is that the technology enables the app, and the app becomes a catalyst for new thinking about the collection and the mission of the museum.

Over the course of the past two decades or so, two often-discussed avenues of thought have emerged in the museum community in relation to digital technology. One sees the growth of the virtual experience as a threat to the face-to-face encounter with real artifacts, eventually making the virtual experience with the collections the only experience. The other sees the digital experience as a way to reinvest in the collection by creating visual surrogates of objects that can be mined and manipulated for a host of possible purposes, inspiring greater

FIG. 5: *The Great Chicago Adventure*, a 4K digital video that plays daily in a dedicated theater at the Chicago History Museum, features a compass that was used to survey the city in 1830. In the film, the object has the power to transport the main characters through time. Upon exiting the theater, some younger visitors have stopped at the marquee and asked if the object on display has that same power.

interest in the real thing (Figure 5).

Ultimately, these opposing perspectives reinforce the value of objects. It's clear that we widely recognize the significance of collections across the profession, but so far we have failed to articulate what they mean in our increasingly digital world. For those of us who do not think in terms of ones and zeros, we need to make the effort to understand and mine the technology for what it can do. For the technologically proficient, we must help create a community of digitally-savvy staff in all sectors of the museum and foster a collaborative environment in which everyone thinks about both digital space and gallery space as venues for creating meaningful collections-based experiences with and for visitors.

Together we can foster a new, robust relationship between the twenty-first century communities we serve and the collections we care for. After all, it is the assumption that such a relationship exists and has meaning that makes the task of collecting worth doing in the first place.

NOTE

1. Rainey Tisdale, "Do History Museums Still Need Objects?" *History News*, Summer 2011: 19-24.

CHAPTER TEN

WANNA PLAY?
BRIDGING OPEN
MUSEUM CONTENT
AND DIGITAL LEARNING
IN SCHOOLS

Merete Sanderhoff

MY DAUGHTER IS A THIRD grader in a Danish public school. She and her classmates are surrounded by digital technologies. They learn about the world and how it works on tablets, smartboards, and through interactive software. Being a curator in a museum with an amazing collection of artworks and knowledge, I dream of all the things she and her friends could be doing, learning and making with our collections. I am an avid advocate of opening up our cultural heritage to free and universal use across the World Wide Web. I want digitised museum collections to be a gigantic playground for school kids to romp about in.

Reading the CODE | WORDS essays has reaffirmed my conviction that museums must open up their collections and minds to the world. A quick glance at them delivers compelling arguments why we should embrace openness as a strategy for our data, and as a state of mind. Michael Edson and Nick Poole both contribute to defining a much bigger scope for what museums can achieve:

> Museums, libraries, and archives (...) can play a huge role in the story of how Earth's seven billion citizens will lead their lives, make and participate in their culture, learn, share, invent, create, cry, laugh, and do in the future.

> [Museums can] give people places, experiences and tools which help them engage creatively and positively with chaos and change.

Mike Murawski adds how digital has become omnipresent

FIG. 1: Peter Hansen, *Playing Children. Enghave Square*. 1907–08. SMK.
Photograph: CC0/Public Domain.

– not just as technology but as a way of thinking and living life in the 21st century – and therefore an inevitable baseline in museum practice today:

> …we can no longer unplug the effect of digital technologies and Internet culture on the ways we think about and re-imagine museums today… For museums in the 21st century, becoming aware of these changes requires a shift in thinking at all levels – a shift that embraces a wider "digital mindset".

I wholeheartedly agree. For that reason, I feel privileged to be part of a team that is working intently to turn our museum, Statens Museum for Kunst (SMK for short, also referred to as the National Gallery of Denmark), into what Nick Poole calls an "unbounded" institution. As I am writing this chapter, we are putting the finishing touches to our new open image policy, and preparing to establish the technical framework for public access to free download and uninhibited reuse of our Public Domain images. This will enrich the web with ten thousands of quality images of artworks, collected and cared for by the Danish state on behalf of the population, for everyone to learn from, share, play with, and build upon.

I can't tell you how excited this makes me feel. Inspired by Michael Edson's advice to Think Big, Start Small, Move Fast, we have managed to advance from releasing just 160 high resolution images – to test the waters – to articulating a new, open policy for our Public Domain images that is in the process of being implemented. After years of internal discussions, research, pilot projects, and scrutiny of results, we have

come to a mutual understanding that our digitised collections should be where they belong; in the hands of the public. Today, we have a director who promotes promiscuous sharing as a virtue, and speaks with conviction of being an unbounded museum:

> With our digitised collections, we can support people in being reflective, creative human beings. But the precondition is that cultural heritage is common property, and that each and every one of us can use it for exactly what we dream of... Our role is still more to facilitate public use of cultural heritage for learning, creativity, and innovation. Today, learning happens in reciprocity. We are all a part of the Web. We educate each other.[1]
> – Mikkel Bogh, Director, SMK

Starting small

This open attitude to our collections and societal role has not come about in a snap. As described in detail in "This belongs to you"[2] – my own contribution to the anthology *Sharing is Caring: Openness and sharing in the cultural heritage sector*[3] – it has taken several years to make the decision to change our image policy, and even after passing this milestone we still have a long way to go.

We have taken our first steps into opening up our digitised collections, but at the moment our images come in variable resolutions and qualities. The good thing, however, is that they are clearly marked and tagged as Public Domain. It's a work in progress to digitise and liberate some 200,000 artworks, and we're only at the initial stage. But we decided, in a digital frame

of mind, that we'd rather make ongoing releases of what we have in a less than perfect way than wait until everything is complete and flawless (knowing it will never be). As noted in a recent article on the awesome achievements of the Cooper Hewitt in terms of creating a flexible, multimodal machinery out of their digitised collections, the "team has accomplished so much largely by accepting imperfection."[5]

However, a point that is made repeatedly in the CODE | WORDS essays is that we are not just in need of opening up our assets in order to have more social impact. It is also, and urgently, a question of survival in a changing cultural environment. As Ed Rodley bluntly puts it:

> If we've learned anything about species evolution, it is that those species that are most inventive at the reproduction game are also most often the clear winners at natural selection. The same holds true for museums. Survival lies in the widest, most promiscuous spread of the cultural seeds we steward and create.

Rob Stein tackles this issue from another angle, that of impact assessment. Today, when cultural institutions are competing on a global scale not just for the attention of audiences, but for continued government and private funding, it is growing more and more crucial that we are able to tell the world why our work matters, and how it makes a positive difference in people's lives. As he points out, when governments and philanthropists are looking at how to invest their money, the cultural sector is competing with such huge issues as fighting poverty, curing cancer, or equalising global inequality. There

is a growing tendency among funders to prioritize investing in causes:

> ...that can deliver the biggest tangible benefits, believing that a disciplined method of investing in these causes will result in the greatest human impact for good... The problem lies with the cultural sector's inability to mount a compelling case of evidence to convince these "effective altruists" that tangible and meaningful benefit does indeed result from investing in the arts and culture.

An unmissable opportunity

I have always imagined that the first and foremost social benefit of releasing my museum's images into the Public Domain would be the impact this would have on the quality, educational opportunities, and depth of engagement with art in public schools. Imagine my daughter and her friends having big, beautiful, faithful reproductions of artworks from their national gallery right at hand; images that they were free to play with, tag, cut up, remix, and put up anywhere they like – as opposed to the low quality, degraded reproductions they can currently find on the internet. For graphic examples of how widespread this problem is, visit Sarah Stierch's Yellow Milkmaid Syndrome project.[5] Every kid in Denmark is required to go to school for at least nine years, and all will go through education in the arts, in history, and languages where they will encounter artworks and knowledge that stem from museums. With open collections, museums have a unique opportunity to be the providers of the raw materials for these educational journeys – materials that, thanks to their quality, will be truly engaging and enjoyable for

the kids to work with and learn about. Putting these images into the hands of school kids is a strategy for deeper learning. As Taco Dibbits, the Director of the Rijksmuseum collections, has said, "The action of actually working with an image, clipping it out and paying attention to the very small details makes you remember it."

And this is just the beginning. As the source of this content, museums also have the opportunity to enter kids' minds as places or platforms that offer cool stuff to explore and play with, not just in class, but also outside school, because it is available promiscuously everywhere on the web. If we could succeed in turning our digitised collections into a familiar toolset that resides in the kids' minds as something that's always at hand, easy to use, interesting and fun, research indicates that there's a good chance that those kids will grow up to appreciate, enjoy, use, and contribute to culture and the arts. It's a mindset they are likely to pass on to their own children. To me, that would be a compelling case for the tangible and meaningful benefit resulting from opening our digitised collections to the public. We can help create this virtuous circle.[6]

I have recently started investigating what we as a museum can do to help Danish schools use and benefit from all the images that are now out there, freely and openly available. I have been talking to colleagues in our Education department, and people who work with media learning in the Danish public school system, to try and understand the basics of getting this right.

A solid foundation

Before I get specific about the potentials and challenges of using open images for teaching, let me provide a bit of background

about the existing relations between museum education and public schools in the capital region of Denmark, where SMK is situated. Since the early 1970s, a network called *Skoletjenesten* (School Service) has been working to facilitate educational programmes between schools and museums. Today, the School Service encompasses more than twenty museums in Copenhagen and the Zealand region, including SMK, which offer audience-specific education programmes for school classes which bridge classroom work and the museum visit. The aim is to meet school teachers and students *where they are*, providing alternative spaces for learning where engagement with authentic artworks and artefacts is central. Importantly, the goal is also to offer school children and teachers educational frameworks and inspiration for new ways of learning that they aren't familiar with, or didn't know they needed. More than 300,000 school children take part in School Service programmes every year.

In other words, there are solid traditions for didactic partnerships between public schools and museums to which which open images can add new exciting dimensions. Being the National Gallery of Denmark, SMK has a special public service obligation to reach all school kids in the country. Freely available and reusable digital images of the artworks in our collections offer a fantastic opportunity to attain that goal.

Another well-established, didactic institution in the Danish public school system is *SkoleTube* (SchoolTube). SchoolTube is the biggest platform for school teachers and students to upload and share media productions. It hosts more than 500,000 users in a safe environment. Furthermore, it offers a range of multimedia tools for engagement with digital materials. Since SMK started releasing open images in 2012, SchoolTube has been

one of our most enthusiastic users, appreciative of our clear terms of use, and using our images extensively to demonstrate what can be done with their media toolset.

So far, so good. There are longstanding relations between public schools and public museums in Denmark, and their solidity is due to the fact that, fundamentally, our institutions build on similar principles: that everyone in society should have equal access and opportunity to learn, develop and thrive as individuals and citizens.

Bildung meets Building

The Germans have a fine word, *Bildung*, which is impossible to translate precisely into English but which packs into a single word the joint meaning of education, training, and culture. *Bildung* has been at the core of democratic society since its foundations were laid in the Age of Enlightenment, and as Ed Rodley has expressed in his essay:

> Promiscuous sharing is a way of finally delivering on the ambitions of those Enlightenment thinkers who dreamed of universal knowledge diffusion.

With universal access to cultural heritage as raw materials for new creativity and innovation, *Bildung* becomes closely connected to *Building*. Creating an understanding of the world and your own place in it becomes a product of active processing, adapting, rebuilding and repurposing. The word *Bildung* is particularly poignant in this context, since etymologically it is derived from the verb *bilden* (to form or create) which again originates from the noun *Bild* (image). Images, linguistically, are building blocks

FIG. 2: Wilhelm Bendz, *A young artist (Ditlev Blunck) examining a sketch in a mirror.* 1826.
SMK. Photograph: CC0/Public Domain.

for learning. We are formed by exploring and creating images (Figure 2).

Though I have just scratched the surface of the pedagogical potential of open images, my initial research into the field has already revealed some immediate challenges that we need to tackle if we want to turn our open collections into truly useful assets for the students and teachers in our public schools.

New competencies, new frameworks

When my daughter returned to school after the summer holiday last year, it was to a transformed reality. The Danish public school system had been through extensive reforms, and the new version of "public school" began in August 2014. At the core of the school reform is the notion that every kid should be treated as an individual learner. This consolidates a fundamental change in the teacher's role which has been emerging for a number of years: from a classic conveyor of knowledge to a facilitator of learning whose foremost job it is to uncover, in collaboration with the kids, which learning styles bring out the best in each of them. This is also expressed as a shift from *teaching* goals to *learning* goals, with a strong focus on aiding students translate what they learn into practical skills. The classic learning styles of reading, writing and verbalizing ideas is complemented by more active learning styles like visual learning, active listening, hands-on approaches, engaging all the senses, co-creation, and building as a cognitive practice. Simultaneously, IT is emphasized as a cross-disciplinary field of competence (Figure 3).

The idea underpinning open collections is to turn artworks from passively-consumed images into building blocks in the

FIG. 3: Aysar Khalid, *The Building Blocks of Art*. AK-Productions.

hands of users. In my ears, the school reform sounds like it provides a perfect arena for open images to unleash their educational and creativity-fostering potential.

However, I am learning that opening up our collections is just the beginning of a much bigger venture. Turning the vision of democratic access to our shared cultural heritage into a positive impact we can measure, and demonstrating that we have improved the learning opportunities for every school kid in Denmark, is not achieved merely by releasing quality images into the Public Domain. Talking to colleagues from Children and Youth programmes at SMK who are experienced in working closely together with public school teachers to design educational resources and workshops based on our collections and knowledge, has deepened my understanding of what it will take to unleash the full potential of open collections into the hands of school children.

Don't get me wrong; openness is a great starting point. Public schools are always hungry for quality educational resources from trusted sources, and they often work with minimal budgets. So if there are freely available, reliable resources out there, all the better. But there are hurdles to overcome before museum images become truly useful to the public school, and some of them are terrifyingly banal.

We're open!

First, I am learning that museums need to raise awareness that our Public Domain images are out there and may be freely used. While the surge of digitised heritage collections released into the Public Domain is making headlines in the cultural sector, the good news hasn't really caught on outside our own

circles. I often hear myself explaining at length what I do and why it's so important, and receive astonished feedback from the patient people who hear me out: "Can I really go and grab high res images off your website? And just use them for what ever I want? For *free*?" My colleagues who work with school programmes confirm that this lack of knowledge is common among teachers and students alike. The news that many museums and cultural heritage institutions are now sharing quality images freely on the internet simply hasn't reached the classrooms and teachers' lounges yet.[7]

Bigger is better. Or is it?

Second, I am beginning to understand that museums need to cater in a much more targeted way for the specific conditions and needs of teachers and students when working didactically with digital images. If *Bildung* is all about building, we need to build strong bridges between our digitised collections and the school classes where we hope to see them used. One of the hurdles standing in the way of use – one which has come as a surprise to me – is that big image files are not necessarily or always the best thing to offer. The digital tools available in public school media programmes often have limits on the size of image files they can handle. The didactic tools offered in SchoolTube for things like film editing, annotation of images, creating timelines, animations, and mashups, work best with image files no larger than 1600 pixels wide. There is a great focus on the importance of releasing big image files, the bigger the better, to support creative and innovative reuse. But focus is lacking on releasing content that is fit for purpose.

In a recent blogpost, Melissa Terras, Professor of Digital

Humanities in the Department of Information Studies at University College London, asks a really good question: Why are we not witnessing a wave of popular reuse of the masses of digitised cultural heritage that's being released on the Internet?

> We live at a time when most galleries, libraries, archives and museums are digitising collections and putting them up online to increase access, with some releasing content with open licensing actively encouraging reuse. We also live at a time where it has become increasingly easy to take digital content, repurpose it, mash it up, produce new material, and make physical items... What relationship does digitisation of cultural and heritage content have to the maker movement? Where are all the people looking at online image collections like Europeana or the book images from the Internet Archive and going... fantastic! Cousin Henry would love a teatowel of that: I'll make some Xmas presents based on that lot![8]

Having read this post, I realize that one reason is because these images are not fit for purpose. There are millions of cultural heritage images made available online for free, but often they are released with such limited understanding of the needs of their target users that they miss the target. In Melissa's case, she actually requires big PhotoShop-friendly image files, as raw as possible, which are good for clipping and remixing. Danish school kids and teachers require something quite different: images that are formatted to fit the digital tools they have at their disposal. If they can't upload our images to their platforms, or have to deal with reformatting them before they

can get to work, chances are they will give up and go find suitable images elsewhere. Images that will not be authenticated by the museum that houses the original artefact, or link back to the source where in-depth information about the object can be found. We cannot afford this to happen. So, after having spread the word that we offer open images, we need to pack them in formats that suit the toolbox realities of the public school. Bottom line is, if we want our open collections to have a real positive impact on people's lives, we need to work much harder on making it easy for any user to get images that fit their purpose.

Frameworks for reuse

Third, my colleagues in School Service tell me that it is absolutely vital to establish starting points and frameworks for school kids and teachers to work with open images in meaningful ways. Years of experience in running School Service programmes have ascertained that successful learning happens when both sides are equally engaged; when school teachers and museum educators form real teams that develop learning programmes in close collaboration, and share ownership of the resulting didactic designs. This is all the more relevant when we are talking about introducing new media practices that require new skills.

As my colleagues explain, the level of digital literacy in Danish public schools fluctuates considerably. This is backed up by Peter Leth, learning consultant at SchoolTube and a former public school teacher himself. While "digital didactics" is a political buzzword in Denmark, it is still far from implemented into everyday practices in schools nationwide.

According to Peter Leth, only approximately 25% of Danish school kids are exposed to fully deployed digital learning methods today. In his experience, there is a degree of hesitancy or even resistance among Danish teachers to embrace the digitisation of teaching and learning practices. One reason is that digitisation is politically encouraged, and therefore easily perceived as an ideal that is out of sync with everyday reality in the classrooms. It's all well and good to say that the public school must be digital, and to invest in the hardware, but if it isn't followed up with additional means, time, and resources for supplementary training, it won't result in new, sustainable practice.

Public school teachers belong to one of the professional groups in the Danish workforce that are most subject to stress-related illnesses. As one public institution to another, museums can support their efforts to enhance the digital literacy of the next generation of citizens in our society. We can help bring down the risk of a digital divide growing between those students who are trained in the analytical and critical use of digital media and those who are not, something which could significantly influence their choice of further education and opportunity in the job market when they leave school.

It is not hard to understand why many school teachers are struggling to get up to speed with digital didactics – a field that is developing so quickly. Though in principle the new school reform aims to improve and update opportunities for every school kid in Denmark, in practice – and predictably – it has also entailed uncertainty and added pressure among teachers. Having to adapt to changes in long-standing practices doesn't leave much energy for experimenting or trying out new things.

Not an optimal scenario for the bright new potential of open images to unfold in. Taking this into account, museums can take on an active role, not only in offering open images as a free resource to public schools.

Another important way of making open images fit for purpose is to put them at the core of didactic designs which align with the curricula outlined by the Ministry of Education. By suggesting meaningful frameworks for use in accordance with the curricula that teachers and students are required to follow, the images become a useful tool which supports a busy workday instead of being yet another add-on. Sustainable practice would be for museums to co-develop learning designs built around open images with the teachers who are going to use them in their teaching. We should offer and package open images, so they are not just "nice to use", but "need to use".

Black holes

Apart from these challenges, which have to do with packaging and tailoring images for didactic purposes, there is also a fundamental need to educate both teachers and students about proper conduct and attribution when using content found online. Peter Leth has been working for years to raise the level of digital awareness in public schools, drawing attention to the new conditions of teaching in the age of the internet. In his experience, school kids as well as teachers are used to surfing the web for images and copying or downloading the first thing handy, with little or no regard to copyright. This concerns him, because it turns the promise of free and global information search as a learning tool into a potential vice:

The school wants to see and support creative, imaginative youngsters who evolve and learn how to interact with the world. But the school becomes conflicted with itself and its surroundings if it embroils itself and its students in criminal activities. And in fact it will do so every time it hosts an activity where you need to work with information and knowledge that is protected by copyright law.[9]

Teaching students and teachers about the proper use and reuse of online content is not a task for museums. But our open images can help alleviate the problem. As we flood the internet with authenticated, high quality, openly licensed images, they will flush out existing bad copies of the same artworks and objects. By providing a safe alternative to randomly surfing the web for images, museums will reap the benefits of becoming the key online reference point for objects in their collections.

But offering images that are safely in the Public Domain is one thing. Another and more tricky problem is dealing with the so-called "black hole of the 20th century". This term designates all the in-copyright content that is not digitised, not made available online by their rightsholders, or which belong to the category of orphan works. In an educational environment where we want to teach kids to respect copyright, and at the same time inspire them to take active part in reusing and creating culture, it's not enough to make just the old stuff available. We need to address how we can help school kids feel connected to modern and contemporary art as well, and this connection becomes stronger when they can play with it.

The cultural commons is founded on the principle of

diversity and inclusiveness (UNESCO, 2005). In a recent paper by Hans van der Linden, Eva van Passel and Leen Driesen, it is proposed to widen the scope of this principle to encompass diversity and inclusiveness of the resources held in a cultural commons. As they write, a cultural commons:

> ...should not be limited to freely accessible content in the public domain, but should also enable meaningful integrations of material where intellectual property rights still play a role and take into account opportunities for novel artistic creations.[10]

In their paper, they propose to start building the foundations of a *layered commons*, where different content types have different levels of openness, dependent on their rights status – acknowledging that this is going to take a while to realize. On a more immediate level, Melissa Terras suggests that cultural heritage institutions help leverage the demand for reusable in-copyright materials by curating pre-cleared packages of modern and contemporary images so they are ready to use under clearly communicated terms.

If we want kids who appreciate and are curious about culture in all its diversity, we need to bring the full spectrum of cultural heritage into play, and teach them how to act correctly and respectfully while feeling free and uninhibited about using culture. Hopefully, being introduced to reusable digital content from school age in a manner that underlines the value of open licensing *and* proper attribution, kids will be inspired to be both creative, and to share their own creative output under the same liberal terms as the raw materials they

have the benefit of having access to. A beautiful example of a young creative who gets it is the artist Filip Vest (b. 1995),[11] who explores the artistic potential of remixing digitised masterpieces from art collections, and shares his own works under the Creative Commons license CCBY-SA[12] to encourage others to keep building (Figures 4 and 5).

Digital natives?

From a broader perspective, it is vital to raise the general level of awareness of the complexity of seeking and using information on the internet. Critical search and evaluation of online content and information is growing more and more important as a skill. The OECD[13] has defined a set of core competencies which are needed to do well in the networked society of the 21st century. Apart from basic IT skills, these encompass abilities such as critical information search, data wrangling and management, multimodal interpretation, adaptation to changing conditions, self-management, creativity and innovation. Often, there is a tendency to think that these are skills which kids automatically have today, brought up on internet-connected devices as they are. However, new research implies that the generation that has been dubbed "digital natives" may be born into a world that's innately and ubiquitously digital, but that does not necessarily mean they are born with the ability to navigate critically and proficiently in the digital realm. At least in Denmark, studies show that many school kids lack basic skills in evaluating the validity and credibility of the information and sources they find online.

Once again, there is an obvious opportunity here for museums to contribute positively to the digital education of school

FIG. 4: Filip Vest, *Artemis.txt*. 2013. Filip Vest created this work from Hammershøi's original in an intriguing process. First, he transformed the huge image file released by SMK (87 MB) from .jpg to .txt format. The resulting text document was several thousand pages long, mirroring the richness of the raw image file. Then he randomly changed digits in the text and transformed it back into a JPG. This is the resulting image. CCBY-SA 4.0.

kids. If there is something museum professionals are aces at, it is critical search and evaluation of source material. Our ability to offer not only truthful renderings of artworks in our collections, but also truthful contexts for them, and an authentic interest in discussing established knowledge and exploring new perspectives, makes museums great partners in digital didactics.

The need to develop digital literacy and skills, of course, goes both ways. Museum educators as well as school teachers

FIG. 5: Vilhelm Hammershøi, *Artemis* 1893–94. SMK. Photograph: CC0/Public Domain.

and students require training in understanding and using digital media optimally for learning purposes. My point is that museums have a common cause with public schools, and the benefits we can gain from investing in this field are evident. For digital didactics to prosper, we need safe and trusted environments where kids can learn how to navigate the internet and sort through the raw materials flowing around there. We can help create those, in close collaboration with school teachers.

A bigger vision

I have always thought of my daughter as a Maker.[14] With

museums opening up their collections, I feel my profession can play an important part in providing building blocks for her creativity and her education to become a happy and reflective citizen. I realize that the idea of digitised collections as a playground may sound like a naïve vision in the face of the dire global crisis outlined in some of the preceeding CODE | WORDS essays. Also, the kinds of challenges I have tried to identify here may seem petty in comparison with those described in the essays of Bridget McKenzie or Rob Stein. But I think we stand on common ground: that museums must get a new perspective on what kind of impact we can make. It is not about us. It is about the difference we can make in people's lives. How our practice can underpin the development of a healthier, more balanced society. To quote Bridget McKenzie:

...the key is not in the question "How can museums survive?", but in "How can museums do work that matters?

To achieve that, we need to start somewhere. And I think a good place to start is by supporting the formation of independent, creative, critically reflective children who are braced for the challenge of building a better world. That's the task we have passed onto them. My aim here has been to start exploring the mechanics of open museum content as educational resource; how we can turn our digitised collections into a brick in the building. I am eager to learn from you – readers of CODE | WORDS – what the conditions for learning with open content are in your communities, and how you think we can demonstrate the social impact of opening up digitised culture.

ACKNOWLEDGEMENTS

Thanks to the people who have informed my research:

Nana Bernhardt, Head of Children and Youth Programmes, SMK

Julie Maria Johnsen, Educator in Children and Youth Programmes, SMK

Jens Christensen, Intern in Children and Youth Programmes, SMK

Peter Leth, learning consultant, Lær-IT and SkoleTube

NOTES

1. http://www.smk.dk/en/explore-the-art/smk-blogs/artikel/mikkel-bogh-blogs-enlightenment-in-the-age-of-digitisation/.

2. http://www.sharingiscaring.smk.dk/en/about-smk/smks-publications/sharing-is-caring/merete-sanderhoff/.

3. http://www.smk.dk/en/about-smk/smks-publications/sharing-is-caring/.

4. http://m.theatlantic.com/technology/archive/2015/01/how-to-build-the-museum-of-the-future/384646/.

5. http://yellowmilkmaidsyndrome.tumblr.com/.

6. I haven't looked into this research yet, but my colleague Nana Bernhardt confirms that in Denmark alone, there are several research projects supporting these hypotheses, including those conducted within the framework of DREAM (Danish Research Center on Education and Advanced Media Materials). She also mentions the research of James Catterall and Anne Bramford as important sources.

7. SMK Children and Youth Programmes and SchoolTube are co-developing a series of learning designs based on open images. The designs will cover several fields of competencies, including language training, written and oral communication skills, and passing from immediate sensual experience to critical analysis.

8. http://melissaterras.org/2014/10/06/reuse-of-digitised-content-1-so-you-want-to-reuse-digital-heritage-content-in-a-creative-context-good-luck-with-that/.

9. Leth has written a useful handbook explaining the Creative Commons system to

school teachers (Danish only): http://www.laerit.dk/cc/.

10. http://static1.squarespace.com/static/52ad3068e4b09df32bf2b17c/t/5400cab3e4
 b0ba5a060636ee/1409338035103/Hans+van+der+Linden+Eva+Van+Passel+Leen
 +Driesen.pdf.

11. http://www.filipvest.dk/.

12. https://creativecommons.org/licenses/by-sa/4.0/.

13. The European Organisation for Cooperation and Development.

14. https://www.youtube.com/watch?v=drSmJe5Cows.

REFERENCES

Olga Dysthe, Nana Bernhardt & Line Esbjørn, *Dialogue-based teaching. The art museum as a learning space.* Copenhagen: Skoletjenesten, 2012.

Karin Tweddell Levinsen, "It i undervisningen", *Dansk Magisterforening*, 08 May 2012.

Peter Leth, "Open licenses, open learning" in *Sharing is Caring: Openness and Sharing in the Cultural Heritage Sector*, Copenhagen: SMK, 2014.

Hans van der Linden, Eva Van Passel & Leen Driesen, "Towards a Cultural Commons Approach as a Framework for Cultural Policy and Practice in a Network Society", Proceedings of the 2nd Thematic Conference on Knowledge Commons, New York, 5-6 September 2014.

Cecilie Cronwald, "Myten om de digitale indfødte", *Weekend Avisen*, 21 November 2014.

Robinson Meyer, "The Museum of the Future Is Here", *The Atlantic*, 21 January 2015.

EMBRACING
A DIGITAL MINDSET
IN MUSEUMS

Mike Murawski

AS THE CLASSIC AMC series *Mad Men* aired its midseason finale back in May 2014, more than two million viewers were graced with an unexpected song and dance performance from senior advertising executive Bert Cooper, played by actor and past Broadway star Robert Morse. In this musical equivalent to hitting the pause button on the much-anticipated final season of this epic television series, Morse crooned the lyrical lines first written in 1930: "The moon belongs to everyone; the best things in life are free."

For me, it was certainly one of the most intriguingly beautiful and surprising moments on television in recent years. The song comes during the last two minutes of an episode in which the daily dramas of the show's characters are laid on top of, and intertwined with, the 1969 *Apollo* 11 moon landing. At one point in the episode, everyone gathers around a television, wherever they are, to watch Neil Armstrong take that small step onto the surface of the moon – engaging in one of the most memorable shared human experiences of the 20th century (an estimated 600 million people worldwide were watching the moon landing live on television at that very moment). Technology, engineering, and new media undeniably acted to create a profound connection. In her *Los Angeles Times* column about the *Mad Men* episode, Meredith Blake wrote:

> It was an unexpectedly hopeful hour of television, one that reaffirms the possibility of positive collective experience while contradicting the notion that technological progress must come at the expense of human connection.[1]

This perspective particularly resonated with me at a time when I was grappling with the effects of digital technologies and media on the educational role of museums. Are my own core values of human connection, shared experience, and community co-creation a part of the digital transformation happening in museums? When we're overly suspicious of digital technologies, are we missing out on a greater opportunity to embrace a "digital is everywhere" mentality – a mindset that brings together thinking about digital technologies and the new ways in which humans connect, share, and learn in a digital age?

Yes, and yes.

Well... how did I get there?

In May 2013, I gave a talk at the Museum of Contemporary Art in San Diego (followed by a short thinking piece online)[2] entitled "Museums Un/Plugged: Are We Becoming Too Reliant on Technology?" which explored my uncertainties about the growing emphasis on technology in museums. Far from being anti-technology, I was, however, exploring some burning questions I, myself, had about the role of digital technology in museum learning and visitor engagement through the polemical dichotomy of "plugged in" versus "unplugged." Among many questions, I asked:

> As we focus more and more on digital and online experiences, are we sacrificing any of the human-centered elements that have been at the core of museum education for more than a century? If your museum lost power, how would that affect the learning experiences in the galleries and across programming?

After seeing some museums investing more in a single digital project than other museums have in their entire annual operating budget, I was genuinely concerned that we might be losing sight of the basic unplugged human interactions at the core of learning which allow these institutions and their collections to have public value and mean something to the communities they serve. I even wrote, "when I head into the galleries to facilitate a learning experience, technology often falls away and I find myself focusing entirely on the analog elements of museum teaching."

Yet, I have come to realize that we can no longer unplug the effect of digital technologies and internet culture on the ways we think about and reimagine museums today. If the lights go out in the museum and all the WiFi hotspots and screens go dark, we might lose the physical technology infrastructure, but we do not lose the powerful participatory, networked, open source culture that has taken root in our audiences and communities in the 21st century. In this regard, digital technology cannot simply fall away.

In the 2014 *Let's Get Real 2* report developed from the second Culture24 Action Research Project involving 22 arts and cultural organizations, experts from across the field noted that institutions are struggling to embrace the new realities of audience behavior (via the web, mobile devices, social media, etc.). Jane Finnis, Project Lead, remarks in her foreword to the report:

> This challenge is absolutely not about technology, which we are often guilty of fetishising as a solution to problems. It is first and foremost about audience and the

ways in which digital technologies are changing their behaviours: at work, at home, on the move, learning, playing, questioning, socialising, sharing, communicating. Forever.[3]

For museums in the 21st century, becoming more aware and responsive to these changes requires a shift in thinking at all levels – a shift that embraces a wider "digital mindset." This approach envisions a deeper fluency and understanding of web behaviors, mobile behaviors, and social media behaviors across all areas of museum practice, rather than their being relegated to the IT, online collections, or website functions of a museum. In her core essay from the 2014 *Sharing is Caring* anthology (a must read, by the way) entitled "This Belongs to You: On Openness and Sharing at Statens Museum for Kunst," Curator of Digital Museum Practice Merete Sanderhoff sets out to define "a new foundation for our work, one that comprises digital infrastructure and a digital mindset in equal measure." She continues:

> Technology should not govern the museums' work. But in order to learn and understand how we can use new technologies and benefit from the opportunities they open up for us, we must explore and incorporate not just technologies themselves, but also the changes in behaviour and expectations they prompt in users. We must think like users.[4]

So how might we begin to think more like users, and see our audience as users, as well?

Be more open

With the rise of the internet, the phrase "open source" began as a way to describe open access to software source code and the collaborative model for how it is developed. Key elements of this development model have been: universal free access and redistribution of the source code, an openness for users to modify and adapt that blueprint in any way desired, and an emphasis on transparency and collaboration.

In museums today, one of the direct effects of this open source movement can be found in the ways through which institutions have released their collection data. As the OpenGLAM (Galleries, Libraries, Archives, and Museum) initiative coordinated by the Open Knowledge Foundation asserts:

> The internet presents cultural heritage institutions with an unprecedented opportunity to engage global audiences and make their collections more discoverable and connected than ever, allowing users not only to enjoy the riches of the world's memory institutions, but also to contribute, participate and share.[5]

In 2013, the Rijksmuseum released 150,000 copyright-free, high resolution images of public domain works – one of several art museums that have made collection data and images openly available online (Figure 1). But they have gone beyond simply releasing images and data, and actively encouraged people to share their collection, remix the artworks to create personalized collections, print reproductions (including everything from posters and canvas prints to coffee mugs and bed covers),

FIG. 1: Screen capture from RijksStudio. www.rijksmuseum.nl/en/rijksstudio. Accessed 17 October 2014.

and allow artists free reign to use these images to create something new. As of October 2014, visitors had created more than 169,000 new virtual exhibitions through the RijksStudio web platform. Ed Rodley's chapter in this volume, *The Virtues of Promiscuity*, lays out an interesting case for museums like the Rijksmuseum being promiscuous with its collection.

Pushing open use of a collection even further, in January 2014 the Walters Art Museum hosted its second Art Bytes hackathon to bring together technology and creative communities to use the museum's rather new API to create games, Twitter bots, scavenger hunts, 3D prints, web apps, eBooks, digital docents, etc. This competition not only used collection data to inspire community-wide creative rethinking about the Walters, but it led to a whole series of incredible adaptations, recreations, and visitor experiences with the collection at the core.

One of Denmark's leading IT lawyers, Martin von Haller Grønbæk, writes in his essay "GLAMourous Remix: Openness and Sharing for Cultural Institutions" from the 2014 *Sharing is Caring* anthology:

All cultural institutions should endeavor to be as open as possible in the sense that as many people as possible should have the easiest access possible to the institution's content. At the same time the institution should seek to ensure that the freely available content is shared, enriched, and processed by users, whether they are citizens, students, scholars, researchers, or commercial ventures.[6]

If we think of the concept of "open" in the broadest way

possible (beyond releasing collection data), it has the potential to challenge museums to let go of some of their control and the limitations that come with this control. Embracing a mindset of openness changes the way we think about museum practice, inspiring a more participatory mentality focused around creating, transforming, and adapting – without the traditional restrictions that have limited forms of public cultural learning.

Redefine authority

> With the web has come a new collaborative approach to knowledge generation and sharing, a recognition of multiple perspectives, and an expectation by users that they will be able to contribute and adapt/manipulate content to meet their own needs.[7]

A hundred years ago, people relied on museums as a repository for the knowledge and information related to its cultural collections. If you wanted to learn more about the artists, artworks, cultures, and places of its collection, you walked inside a museum's grand halls of knowledge. Today, that has completely shifted. Visitors can access far more information through their smartphone or mobile device than any museum could ever hold (as of October 2014, 87% of people in the US use the internet, 67% own smartphones, and they have access to more than 672 billion gigabytes of data from more than one billion websites).

During a visit to the Nelson Atkins Museum of Art in Kansas City, I found myself sitting in front of an amazing Franz Kline painting entitled *Turin* in their Abstract Expressionism

collection. While the pithy 98-word unattributed "voice of god" label offered a few tidbits ("Kline used commercial house paints," and that the painting was "named after a city in northern Italy"), I quickly went to my iPhone to search for more – I was hungry for more. From the 350,000 Google search responses, I instantly found videos, photos, Wikipedia entries, curatorial essays, poetry, music, visitor comments, slow looking reflections, and links to dozens of other museums that had works by Kline in their own collections. While I may have been standing in the Nelson Atkins building, I found myself reaching outside of its walls and connecting digitally with a wide distributed network of authorities and communities of knowledge – even sharing my own content to this mix with tweets and Instagram photos. When I sat down with docents in front of this painting for deeper conversations, we opened up further layers of thoughts, insights, and questions that were not part of the authoritative knowledge repository of the museum.

We have rapidly moved out of the era of passive consumption of content selected by a few experts, and museums now have an opportunity to actively reshape their own authority in this new equation. The digital age does not negate the authority of museums and curatorial expertise, but, rather, it puts this authority in public conversation and dialogue with a wider network of knowledges, voices, and experiences. Cultural authority is not something solely established by a didactic label, curatorial essay, or published catalog; it is negotiated through discussion and collective participation, and shared with our community and the users (yes, I said "users" instead of "audience")[8] with which we connect. In his 2009 essay "A Manual for the 21st Century Gatekeeper," New York-based

FIG. 2: Memory Jar Project, Santa Cruz Museum of Art and History.
http://museumtwo.blogspot.com/.

curator Michael Connor explores the ways in which the internet, social media, and new collaborative ways of working are fundamentally changing the relationship between arts organizations and their audiences. He writes:

> A curator's authority pales in comparison to the audience's vast collective stores of knowledge and passion. How can gatekeepers redefine their role in ways that harness the power of the audience without losing the sense of subjectivity and personal risk that lie behind aesthetic decisions?[9]

As museums work towards sharing authority, they can begin to allow the voices of specific communities and the public to be heard inside the walls of these institutions – to speak for themselves. In her guest editor preface to the July 2013 issue of the *Journal of Museum Education* focused on this theme of "shared authority," Elizabeth Duclos-Orsello includes a powerful quote from historian Karen Halttunen which relates to the role museum staff play as workers in these public institutions:

> We [must] divest ourselves of the special authority sometimes granted to us... [and we must] enter democratic partnerships with other members of our communities.[10]

For me, the Memory Jar Project (Figure 2) a couple years ago at the Santa Cruz Museum of Art and History really stands out in terms of a museum working to renegotiate traditional, monolithic structures of authority (using a digital mindset in an analog way). Part of a larger community-sourced

exhibition project called Santa Cruz Collects, visitors were invited to "bottle up" a memory in a jar, label it, and leave it as part of this exhibit to share with others.[11] The Portland Art Museum's Object Stories initiative also continues to strive toward shared authority and multiple voices.[12] By redefining authority through these processes of co-creating knowledge and meaning with the community, a museum has the potential to be *far* more than just a place that holds and disseminates knowledge.

Get connected

At the core of the digital age are new ways of relating to one another, new ways of interacting, new kinds of groups, and new ways of sharing, learning, collaborating, and connecting. In their 2012 book, *Networked: The New Social Operating System*, Lee Rainie and Barry Wellman argue that the large online social circles of familiar platforms such as Facebook, Twitter, or Pinterest actually expand opportunities for learning, problem solving, and personal interaction. Their work at the Pew Internet Project and the NetLab (especially research for the Connected Lives Project) suggests that digital technologies are not isolated – or isolating – systems, but rather networked systems built upon these social networking platforms as well as mobile device technologies:

People's relationships remain strong – but they are networked. Neighbors, and neighborhoods still exist, to be sure, but they occupy a smaller portion of people's lives. It is hard to borrow a cup of sugar from a Facebook friend 1,000 miles away, but it has become easier to socialize, get advice, and exchange

emotional support at whatever distance. Where commentators had been afraid that the internet would wither in-person ties, it is clear that they enhance and extend them.[13]

Through countless digital projects and social media activities, museums are tapping into global networks and becoming more connected to this growing virtual community (that, in many cases, actually has a strong relationship with a museum's physical community). As Paola Antonelli, senior curator of architecture and design at the Museum of Modern Art, stated in a 2014 New York Times piece, "We live not in the digital, not in the physical, but in the kind of minestrone that our mind makes of the two."[14]

Through the Portland Art Museum's recent #capturePark-landia project, we were able to effectively explore the interconnected network of interest-based social media communities (via Instagram) and the physical communities in Portland itself.[15] The overall reach of this project through Instagram was far larger than the museum's annual in-person attendance, motivating us to rethink how we define our audiences and the new ways in which we might bring them together through moments of exchange. Rob Stein explores related ideas in his essay *Museums... So What?* in this volume:

> ...the face-to-face dialog that happens in real life at the museum is critically important, but I keep thinking about all the ways we could enhance and improve this dialog digitally and online. What if we considered how we might detect when meaningful discourse happens in our social media and online activities?

The Question Bridge project is a particularly powerful example of using digital technologies in a participatory way to bring people together in dialogue and exchange. Organized by artists Chris Johnson and Hank Willis Thomas in collaboration with Bayeté Ross Smith and Kamal Sinclair, this innovative transmedia art project aims to facilitate a question-and-answer dialog between black men from diverse and contending backgrounds and create a platform for representing and redefining black male identity. In addition to its online interactive site,[16] the project has been installed at over 25 museums and galleries, including the Brooklyn Museum, Fabric Workshop and Museum, Milwaukee Art Museum, Oakland Museum, Cleveland Museum of Art, the Exploratorium, and the Missouri History Museum, and includes a multiple-screen video installation as well as a youth development curriculum and specialized community engagement events. The project (about which I encourage you to learn more) is all about dialogue and listening, and it taps into both technology *and* a digital mindset in order to enhance the connective and collective experience of participants in a digital age.

In her book *Museums in the Digital Age*, Susana Smith Bautista discusses how notions of place, community, and culture are changing for museums in the digital age. In her conclusion, she writes:

> If museums are to remain relevant, vital, and meaningful, then they must adapt to a changing society, which means not only recognizing and incorporating new digital tools for communication, but more importantly, recognizing the changing needs and aspirations of

society as reflected in their communities of physical and virtual visitors.[17]

As the behaviors of our audiences and communities change, so do the ways in which they learn. A core part of this digital transformation in museums involves expanding our concepts of learning and engagement to be responsive to an internet culture defined by participation – and not just "participation for the sake of participation," but as serious involvement in the deep, connected forms of cultural and creative learning that can occur with museums.

Embracing a digital mindset of openness, participation, and connectivity allows museums the chance to extend the boundaries of what is possible, and serve as sites for profound human connection in the 21st century – in much the same way that new technologies brought people together for that powerful shared moment 45 years ago to witness Neil Armstrong's giant leap.

After all... *the moon belongs to everyone.*

NOTES

1. Meredith Blake, "'Mad Men' recap: 'The moon belongs to everyone'," *Los Angeles Times*, 26 May 2014, published online. http://www.latimes.com/entertainment/tv/showtracker/la-et-st-mad-men-waterloo-moon-landing-20140525-story.html#page=1.

2. Mike Murawski, "Museums Un/Plugged: Are We Becoming Too Reliant on Technology?," ArtMuseumTeaching.com, 6 July 2013. http://artmuseumteaching.com/2013/07/06/museums-unplugged/.

3. Jane Finnis, foreword to *Let's Get Real 2: A journey towards understanding and measuring digital engagement*, published in 2014 after the second Culture24 Action Research Project. http://weareculture24.org.uk/projects/action-research/phase-2-digital-engagement/.

4. Merete Sanderhoff, "This Belongs to You: On Openness and Sharing at Statens Museum for Kunst," in *Sharing is Caring: Openness and sharing in the cultural heritage sector*, ed. Merete Sanderhoff (Statens Museum for Kunst; National Gallery of Denmark: Copenhagen, 2014), 23.

5. OpenGLAM Principles. http://openglam.org/principles/.

6. Martin von Haller Grønbæk, "GLAMourous Remix: Openness and Sharing for Cultural Institutions," in *Sharing is Caring: Openness and sharing in the cultural heritage sector*, ed. Merete Sanderhoff (Statens Museum for Kunst; National Gallery of Denmark: Copenhagen, 2014), 142.

7. Graham Black, *Transforming Museums in the 21st Century* (Routledge: New York, 2012), 6.

8. Alexa Schirtzinger, "An Audience of Users," *Medium*, 18 October 2014. https://medium.com/@aschirtz/an-audience-of-users-8678218d9824.

9. Michael Connor, "A Manual for the 21st Century Gatekeeper," *Home Media*, 1 October 2009. Link: http://homemcr.org/media/a-manual-for-the-21st-century-gatekeeper/.

10. Elizabeth Duclos-Orsello, "Shared Authority: The Key to Museum Education as

Social Change," *Journal of Museum Education*, Vol 38, No 2 (July 2013), p. 123.

11. See Nina Simon, "Adventures in Evaluating Participatory Exhibits: An In-Depth Look at the Memory Jar Project," *Museum 2.0* Blog. http://museumtwo.blogspot. com/2014/06/adventures-in-evaluating-participatory.html.

12. See Deana Dartt and Michael Murawski, "Portland Art Museum - Object Stories: Connecting Collections with Communities," in *Interpreting Native American History & Culture*, ed. Raney Bench (New York: Rowman and Littlefield, 2014), p. 78-87.

13. Lee Rainie & Barry Wellman, *Networked: The New Social Operating System*, 2012.

14. Steve Lohr, "Museums Morph Digitally: The Met and Other Museums Adapt to the Digital Age," *New York Times* (23 October 2014).

15. See Kristin Bayans and Justin Meyer, "#captureParklandia: A Dive Into Social Media and Place-Based Digital Engagement," ArtMuseumTeaching.com, 29 July 2014. http://artmuseumteaching.com/2014/07/29/captureparklandia/.

16. http://questionbridge.com/.

17. Susana Smith Bautista, *Museums in the Digital Age* (AltaMira, 2013), p. 225.

THE VIRTUES OF PROMISCUITY OR WHY GIVING IT AWAY IS THE FUTURE

Ed Rodley

THE DUTCH ARTIST Theo Jansen has spent the past 25 years creating wind-powered kinetic sculptures he calls *Strandbeests*. These walking constructs gather wind energy to propel themselves across the beaches of Scheveningen and can walk, store energy, and detect atmospheric changes now. Jansen works at an interesting intersection of art, engineering, and science and his artistic practice is deeply influenced by biological metaphors. He refers to his creations as "creatures" and the ubiquitous PVC wiring conduit he builds them from as the "protein" of Strandbeests. They become "fossils" once he stops working on them, and new beests inherit traits from older ones, "evolving" from earlier forms. Jansen thinks a great deal about survival.

Despite their very site-specific nature, the web has provided Jansen with a global audience for his creations. There are approximately 25,000 YouTube videos of Strandbeests in action.[1] You can find versions of his creations in robotics labs in Berkeley and Cambridge. You can order build-it-yourself kits from Japan (Figure 2),[2] and now you can even order 3D printed Strandbeests directly from the artist.[3] This online success has spawned exhibitions in Europe, Japan and North America. Success, right? For now. But, Jansen is looking even further ahead, to the future of his creations after his death. Ask Jansen about the future of Strandbeests and he will tell you that the survival of his creations beyond his lifetime is now possible through the "viral" propagation of digital files that contain the "DNA" of his creations, DNA which he has posted on his website for the world to use, adapt, and remix. The internet has brought him not only an audience, but also a new means of reproduction for his Strandbeests. He likes to claim that the Strandbeest started

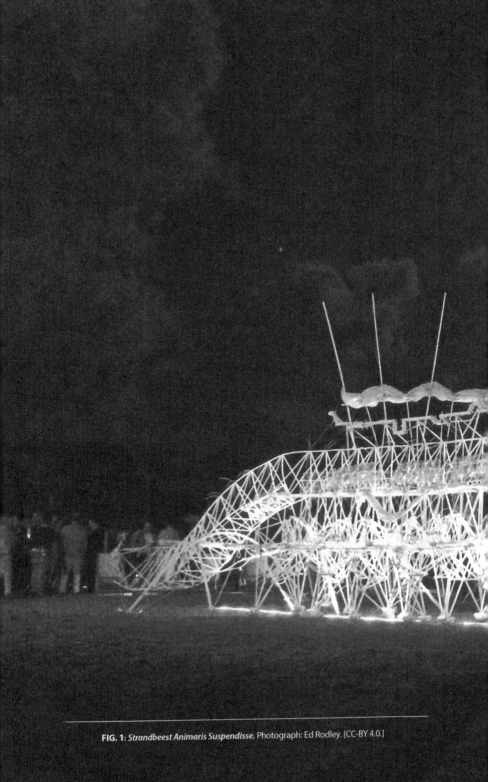

FIG. 1: *Strandbeest Animaris Suspendisse.* Photograph: Ed Rodley. [CC-BY 4.0.]

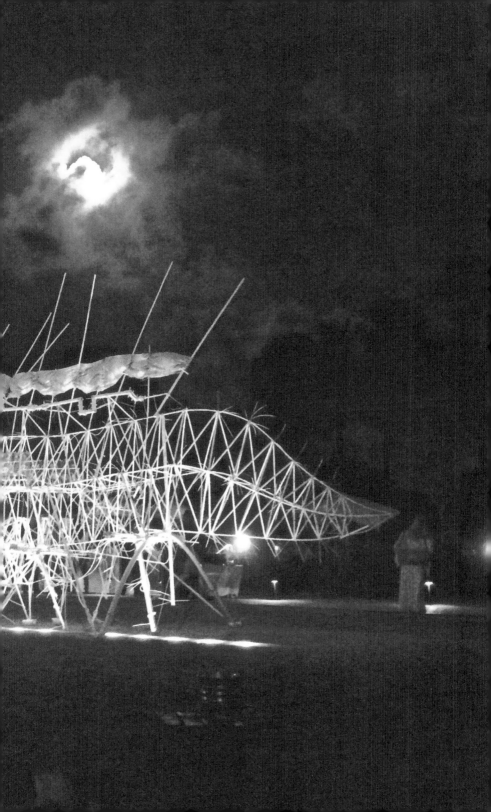

reproducing behind his back "while [he] wasn't looking," but it was made possible by his openness.[4] This sharing of digital DNA might seem counterproductive to a working artist, since it will make it easier for others to copy his work, potentially reducing the value of "authentic" Strandbeests. For Jansen, the long-term benefits outweigh any potential short-term loss of control or revenue. Jansen's interests lie in creating art and exploring ideas around the nature of life and living systems. Given finite time and resources, he chooses to prioritize the making and let the rest go and grow however it will.

Being promiscuous, but discriminating

Museums could do well to learn a thing or two from Jansen, and focus more on the creating and spreading the "digital DNA" of our shared cultural heritage and less on controlling access to those assets. This chapter is a call to be both more promiscuous and more discriminating in what we share and how. I know that sounds contradictory, but bear with me.

Museums' current survival strategy is not unlike those of creatures that have evolved on remote islands. We have gotten very good at passing on one model of "museum" from generation to generation. We may have developed elaborate plumage and interesting displays, but these mask the underlying sameness of the idea we pass on. As long as the larger ecosystem evolved slowly, museums could adapt and keep pace. The global internet has shattered that isolation for good, and in the new ecosystem our current reproductive specialization will not continue to serve us well. Insularity – the tendency to look inward, ignore the larger world and produce institutions that are increasingly self-referential, self-pleasing, and

obscure to the billions of potential museumgoers – is a strategy for extinction.

Desi Gonzalez asked of the original version of this essay:

> So while museums may have added bells and whistles over the years, they still do fundamentally the same thing. But what exactly is that? (In other words, what makes a museum a museum?) And if we radically alter that, as you seem to be suggesting here, do we still have a museum?

It's a great question, given the continuing debates in the cultural sector in general, and museums in particular, about relevance, the role of the community, and other hot button topics that challenge in any way the dominant 20th century model of (primarily art) museums as secular temples. What counts as being a "museum" is the result of a negotiation between society, the institution and its audiences. It has been renegotiated several times since the ancient Greeks coined the word *mouseion*, and we are living through another one of those renegotiations: the transition from the predigital to the postdigital. In moving from a culture of scarcity to one of abundance, where (seemingly) everything is or will be discoverable online, our 19th- and 20th-century models of "museum" will need to transform if we hope to evolve along with the larger society, and hopefully have some positive impact on that evolution. A cornerstone of that strategy will have to be a more promiscuous attitude toward sharing our digital assets.

For Theo Jansen, encouraging others to build on his idea of Strandbeests is a reproductive and evolutionary strategy. His

FIG. 2: A commercially available Strandbeest kit. Photograph: Dave Fayram. [CC-BY 2.0.]

best hope for the survival of his creations beyond his lifetime is to let them loose for others to tinker with. Survival (and further evolution) lies in spread, letting his creations reproduce "behind his back." Cynthia Coburn gave a fascinating talk at the MacArthur Foundation's Digital Media and Learning conference in 2014 on scale and spread. If you're at all interested in the dissemination of ideas, it's worth reading. One thing that struck me from her talk, and the paper from which it was distilled, is that we tend to be imprecise about what we mean when we talk about "doing more." Unpacking that, Coburn finds that there are "fundamentally different ways of conceptualizing the goals or outcomes of scale. We identify four: adoption, replication, adaptation, and reinvention."[5] In this chapter, I'm most interested in the fourth outcome. This way of thinking about spread Coburn describes as, "the result of a process whereby local actors use ideas, practices, or tools as a jumping-off point for innovation."

If we've learned anything about species evolution, it is that those species that are most inventive at the reproduction game are also most often the clear winners at natural selection. The same holds true for museums. Survival lies in the widest, most promiscuous spread of the cultural seeds we steward and create. Think of the internet as a new landmass risen from the sea. It is rapidly being populated by all sorts of ideas and content. There is both room enough and need enough for museums to colonize that land.

Ideas having promiscuous sex

I realize I'm being a bit provocative in claiming "promiscuity" – with all its sexual connotations – as a virtue,[6] but it's apt. In its earliest sense, promiscuous meant "things mixed

together." In this sense, to be promiscuous is to be for mixing things up. For me, being promiscuous means spending more effort on creating and spreading, and less on trying to control access. A central part of the missions of successful museums in the present century will be, as Will Noel puts it, "to put the data in places where people can find it – making the data, as it were, promiscuous."

Rachel Ropeik and others have questioned this assertion, asking if sharing wasn't already a core belief of museums, so let me clarify. The sharing which has traditionally happened has been very selective, tightly controlled, and *always* on our terms. In other words, the opposite of promiscuous. Promiscuity requires a fundamental change in museums' DNA. Generations of our predecessors worked in a culture of scarcity where controlling access to information was a kind of authority. The 21st century already doesn't work that way.

Trade in ideas is possibly the distinguishing variable that separates humans from every other species. Evidence for trade amongst humans is ten times older than the earliest evidence of farming. Matt Ridley, the author of *The Rational Optimist*, gave a great TED talk in 2010 where he claims that the engine of human progress and prosperity has always been, and continues to be, "ideas having sex with each other."[7] The ability to share ideas, combine them, and recombine them in new ways has been humanity's key to survival and evolution. Sharing, not technology, has been the key. That's an important point to keep in mind. Technofetishists (many of them well-financed) would have us believe that new technologies will solve all humanity's woes. Early humans used the same lithic technologies, unchanged, for almost a million years: 30,000 generations of

making and using the same tools for the same jobs. We're no longer using Acheulean hand axes, because humans developed the ability to trade things and concepts, and that has led to where we are now. For museums, the situation is analogous in many ways to the Paleolithic. Continued evolution will require us to think differently, develop new tools, and most importantly, trade our goods as widely as possible.

Promiscuity is contagious
Adaptation requires not only opening access to resources, but also a readiness to adapt institutional practices based on that openness. Providing access is easier than changing practices, which is why you see more examples of it in the wild. We are starting to see the first fruits of openness driving institutional change. The number of museums establishing "labs" as incubators of new ideas and practices keeps growing. The Andy Warhol Museum's latest digital strategy document,[8] that most internal of internal documents, is a GitHub repository which can be studied and modified ("forked" in software terms) by anyone interested in building on it. It's catchy.

I've personally experienced the difference. In a one year period, the Peabody Essex Museum hosted exhibitions on the works of Alexander Calder and Theo Jansen, both artists who made kinetic sculpture. The former's estate is largely controlled by a foundation set up to protect the integrity of the artist's work, the latter by an artist who encourages people to take his work and remix it. The museum's responses to those two situations are instructive and I think generally applicable. In the case of Calder, faced with contractual obligations to submit every image and idea for approval, the museum presented the

works in a very traditional setting. In Jansen's case, his openness infected the entire process, the result being an exhibition that is far from traditional. Curatorial texts were replaced with videos of the artist discussing his process and motivations. The museum hired new staff to operate and interpret the Strandbeests and let visitors operate them as well. A string of pop-up events were hosted where we brought the objects out into the community. A hackathon occurred in conjunction with the opening events, with teams competing to build their own new species of Strandbeest. Even efforts that didn't bear fruit, like a major digital presence, resulted in our staff working together in new ways and raising our gaze to see new possibilities. The benefit that accrued to the institution will live long past the closing date of the exhibition.

The virtues of promiscuity

When I wrote the first version of this essay in 2014, it was with a sense that there was an urgent need to advocate for museums to do more to promote openness, transparency, and agency among our audiences and ourselves – what I chose to call digital promiscuity. What I couldn't articulate clearly enough for myself, or for commentators like Koven Smith, were the arguments that backed up my claims. I couldn't describe the overarching justification for promiscuity well enough, and was left with an essay that did maybe 80% of what it needed to do. In the time since then, it has become clear to me that the missing piece was the unstated goal of institutional transformation that promiscuity makes possible. This kind of transformation is, at it's most fundamental level, not about digital technologies, but about people, mindsets, relationships, and things.

Promiscuity is not the goal in and of itself. Promiscuity is a mindset that is one of the first steps of transforming your museum into the postdigital institution it can become. It's an essential prerequisite for the larger goal of transformation of museums from predigital to postdigital institutions.

The promiscuous spread of digital assets is a key factor in *delivering on museums' missions* to educate, inform, stimulate, and enrich the lives of the people of the planet we live on. Merete Sanderhoff, in the excellent *Sharing is Caring* book lays it out clearly:

> Digital resources should be set free to form commons – a cultural quarry where users across the world can seek out and find building blocks for their own personal learning.[9]

The more we sow these seeds of culture and the more effective we are at seeing those seeds take root, the more likely museums are to see cultural ideas persevere in the constantly-changing world.

Promiscuity is one way to *demolish the perception of exclusivity* which has dogged museums for longer than I've been around. I realize that this virtue is by far the most painful, because it would force us as memory institutions to lay bare lots of things of things we'd rather not have to deal with: legacies of imperialism and colonialism, tensions between indigenous peoples and more recent arrivals. The history of the relations between native peoples and museums is not the most cordial, at least in part because the *perception* that some museums are probably hiding things they don't want tribes to know about

is almost impossible to counter. Promiscuity offers a way to end that particular debate.

The "global village" which the internet has created is real, and now it is possible for a museum of any size *to have global reach*, provided they have anything to share. As Michael Edson pointed out in his introduction to *Sharing is Caring*, 34% of humanity is now reachable online. That's 2.4 billion people who might be interested in your content.

One of the most interesting and infuriating changes in attitude that the web has wrought is the expectation of finding everything. *Not being visible online now is the equivalent of not existing.* Promiscuous sharing of digital assets is a way for your audience to know you exist. As Will Noel says:

> ...[P]eople go to the Louvre because they've seen the *Mona Lisa*; the reason people might not be going to an institution is because they don't know what's in your institution. Digitization is a way to address that issue, in a way that with medieval manuscripts, it simply wasn't possible before. People go to museums because they go and see what they already know, so you've got to make your collections known. Frankly, you can write about it, but the best thing you can do is to put out free images of it. This is not something you do out of generosity, this is something you do because it makes branding sense, and it even makes business sense.
> To be public these days is to be on the Internet. Therefore to be a public museum your digital data should be free.[10]

Discriminating?[11]

So promiscuity has value to museums. Being successfully promiscuous, though, requires some fine discrimination of the sort that museums have not traditionally been good at.

It's not an either/or proposition

The value of museums doesn't change from being about physical things to being about digital things. It expands from the physical to include spreading digital information about those assets. When I was a newly-minted museum professional, I distinctly recall seeing the slogan for the 1989 ICOM conference: "Museums: Generators of Culture" and thinking simultaneously, "Yes!" and "Yeah. In your dreams!" What was unthinkable in 1989 seems perfectly reasonable 25 years later. The internet allows museums to be promiscuous on a global scale, seed a global cultural commons with the highest-quality building blocks from across the entirety of human endeavor, and finally be able to deliver on that 1989 aspiration. As Michael Edson points out in *Dark Matter*, the first CODE | WORDS essay:

> It's tremendously exciting to think about what we can accomplish if we begin to work with true conviction in the areas of the Internet that are less familiar to us and more familiar to our visitors.[12]

It's mission creep of an unfathomable scale, with all the ramifications that entails. The question museums have to ask are, "Is it worth it for us?" and if so, "How do we proceed?"

It requires us to disambiguate the digital from the physical
Huh? Disambiguating the digital from the physical (to steal
yet another phrase from Koven Smith) is essential to being able
to see the issue clearly. In his MuseumNext 2014 keynote[13] and
subsequent blogposts,[14] Smith warns against the peril of the
skeuomorphic[15] view of digital museum assets and the chal-
lenges of being authentically digital. Mapping real-world
strategies and structures onto the digital realm is not a recipe
for success.

Skeuomorphism has uses. I had the privilege of working
on a couple of projects with major film studios during my
career, and one of the tenets of science fiction filmmaking
which friends at Industrial Light and Magic shared with me
was that to be successful as a film experience, sci-fi had to be
backwards-looking. Everything new and interesting had to
have some real-world analogue it referenced, so you, the audi-
ence, could understand what it was without having to be told.
Thus, spaceships that move like airplanes, weapons that func-
tion like swords and firearms, and aliens who act like humans.
As a storytelling tool, it's great. As a business strategy...

Creating digital analogues of our existing museums is a
straitjacket that will not serve us well going forward. Making a
virtual museum (in addition to sounding hopelessly Nineties),
regardless of the technology underlying it, fails to take into
account the reality of how people consume digital content.
They don't go to museum websites. Jon Voss of HistoryPin once
said to me, "You have to meet people where they are, not where
you wish they were."[16] Museum websites, the traditional place
for museums' online presence, are not those places, so plow-
ing resources into making bigger, swankier ones is a waste of

resources that might be deployed in ways that actually reach a global audience. The monolithic World Wide Web 1.0 has shattered into the vastly more complicated Web 2.0. People looking for museum information may find it first via a search engine like Google or Yahoo, a recommender platform like Yelp or Foursquare, or social media platforms like Facebook or Weibo.

It's not about adding screens

Just as dragging the physcial into the digital is unhelpful, so is carelessly layering the digital on the physical. David Starkey, in an article in *The Guardian* called "Museum of the Year 2014: what makes a winner?",[17] extolls the virtues of the Mary Rose Museum for eschewing digital interpretation and not "whoring after strange gods in museums with every sort of technological device." And he's got a point, to a point. There are plenty of examples of digital technologies being employed to fix perceived problems with museums' physical operations that would have benefited from some additional discrimination in the scoping phase.

It's not about "putting the collection online"

When it comes to sharing access to our assets in the digital realm, as Janet Carding notes in her chapter, *Changing Museums*,[18] most museums still talk about "putting the collection online", by which they mean providing a very ungenerous search interface into subsets of collections data, more than a generation after that became technically possible. We need to do better. Access is important, but a web portal is an oracular cave, shadowy and mysterious. You go into the dark place, ask your question, and the Sibyl answers. Hopefully, it makes

sense. Sometimes, it's a very detailed answer, sometimes not. But the seeker never has the ability to appreciate the collection as a whole, or to interrogate it in any ways other than those chosen by the architects of the Content Management System (CMS) and the portal. And they're black holes to indexers. Google, Yahoo! and Baidu have no way of knowing what lies beyond your search box, and in a world where findability equals existence, this is death. Actually it's worse, it's annihilation – being made into nothing. Not a great strategy for proving relevance.

The collections metadata ≠ the collection

Digital information about collections is not the same as the physical objects in that collection. Here is where I think museums need to be much more discriminating about what they limit access to in the name of preservation, and adapt a mindset and workflows that treats digital assets as part of the cultural commons to be birthed and shared, unless there's a compelling reason not to. Giving away a digital image of a specimen or art object is not the same as giving away the object. As Seb Chan wrote in announcing the Cooper-Hewitt's upload of their entire collections database to the code sharing site GitHub:

> Philosophically, too, the public release of collection metadata asserts, clearly, that such metadata is the raw material on which interpretation through exhibitions, catalogues, public programmes, and experiences are built. On its own, unrefined, it is of minimal 'value' except as a tool for discovery. It also helps remind us that **collection metadata is not the collection itself.**[19]

One of the most interesting developments in this sharing of collections metadata has been the innovative ways outsiders not normally privy to these data have used them to query the collection in ways we insiders might never dream of. With the proliferation of born-digital "objects" I can easily imagine that this kind of openness may cause us to reassess our thinking of what the "collection" is?

The myth of access = control

"We have to look out for the museum's reputation" is one reason I've heard repeatedly for restricting access to assets, be they images or a dataset. The argument goes something like this: by making people ask for access, and charging them for the costs the institution incurs to produce this digital asset, museums discourage casual misuse of these assets by outside parties. This gatekeeping is necessary, and for the privileged few (mainly art) museums with famous collections, this provides a revenue stream that often pays the salaries of those gatekeepers. So, my theoretical position about promiscuity suddenly turns into people's jobs and livelihoods, which is where things get messy. But this kind of access control is anathema to both the Enlightenment ideals that underlie the museum enterprise and the nascent global culture we could become an indispensable part of.

A nice thing about selling access is that it's quantifiable. You can create reports about how much money licensing brought in, how many requests were processed and fulfilled, and so on. The more promiscuously one shares, the harder it gets to measure. Harder, but not impossible. Image spread can be tracked, download statistics and page views can tell you

something, and as more museums get more promiscuous, I'm sure other metrics will be developed to help us quantify the success of our efforts.

But just because something is amenable to measurement doesn't make it the best thing to measure. Here in the United States, there's been a dramatic increase in testing in formal education over the past decades. Standardized tests can measure what students have memorized and produce reports, but that has little bearing on intangibles like thoughtfulness or creativity. On a larger scale there is, to me, a certain logic in promiscuously sharing as the best way to create the most opportunities for the kinds of epiphanies museums can generate. As Rob Stein asked at the Museum Computer Network conference in 2011, "How do we measure for epiphany?" If museums are in the business of inspiring, even changing people, then Stein's call to track and measure alumni creativity in his chapter *Museums... So What?*[20] becomes even more important. David Gerrard, Ann O'Brien, and Thomas Jackson from Loughborough University in the UK proposed a way to study this at the Museums and the Web 2014 conference. Their "Epiphany Project: Discovering the Intrinsic Value of Museums by Analysing Social Media" represents just one approach to measuring what matters.

And if we don't? Merete Sanderhoff lists three problems this inability to be promiscuous creates:

1. By putting up impediments museums are pushing users away from authoritative sources of information.
2. We are missing out on the the opportunity to become hubs for people. The social gravity that museums *could* generate is largely unrealized.

3. By not using these new tools that are at our disposal, museums undermine their own *raisons d'être*.[21]

Kristin Lyng of the Meteorological Institute of Norway writes, "Freeing data can be compared to letting your child go out and play in the playground. You're letting go of control, but you know that it's best for your child to be able to play out in the open."[22] Or, as a participant said in Kristin Kelly's 2013 Mellon Foundation report on image sharing, "We have lost almost all control, and this has been vital to our success."[22]

Who's already reaping the rewards of promiscuity?
Museums releasing large sets of images
Kelly's Mellon report surveyed eleven major museum image sharing projects. One of the key findings was that for all these museums, the decision in the end was mission-driven. In this time of funding challenges, with pressures to be more business-like, and with increased competition, it's heartening to see beginnings of a groundswell. The common trope of "Museum X announces release of ___,000 images from its collection for public use!" is hardly noteworthy anymore.

Museums releasing collections datasets
The Powerhouse did it in 2009,[24] followed by Cooper-Hewitt in 2012,[25] and then Tate later that year.[26] Read the announcements of each, they're interesting justifications of promiscuously sharing. What's really interesting, though, are the reuses of these datasets, because they point to something important. By giving people access to the collection, you give them the ability to ask questions of the museums' work that we inside these museums

FIG. 3: Johannes Vermeer, *The Milkmaid*, c.1660 [detail]. Public Domain, found at https://www.rijksmuseum.nl/en/collection/SK-A-2344.

might never think to ask. Florian Kräutli's visualization of Tate's collecting history was not only a new way to look at Tate, but also uncovered flaws in how Tate's collection data were organized (40,000+ works by J.M.W. Turner?) which a collections manager or information architect could overlook or rationalize.[27] Putting it out in public both surfaced the issue and provided impetus for addressing it. Mia Ridge's attempts to explore Cooper-Hewitt's collections data uncovered painful truths about the messiness we tolerate in our data.[28] Like a bedroom we never let anyone see, collections metadata are all too often kind of a mess.

The act of placing them out in the wild, to be seen and used, opens up our datasets for people to ask questions of them we've never thought of. As John Russick writes in his chapter *A Place for Everything*,[29] the ability to interrogate the Chicago History Museum (CHM) collection dataset might allow people to ask questions not just about the objects in the collection, but the collection as a whole, and by extension, the museum itself. And what they might find might not please us:

> CHM's collection is supposed to be a tool for under-
> standing the city, but perhaps it is primarily a tool for
> understanding the museum. Our idiosyncratic collect-
> ing history would likely be revealed as racist, sexist, and
> driven by the ideals and lifestyles of the privileged class.
> But what if we shared that map with everyone? What if
> the entire city could see what is and what is not in the
> museum? What if they could fill in the missing parts?
> Could we both confront our 19th- and 20th-century ideas
> of inclusion and representation and begin to rectify the
> shortcomings of that limited vision?

The Rijksmuseum

The 800-pound gorilla of promiscuous sharing is the Rijksmu-
seum's Rijksstudio platform, a one-stop shop for image asset
use and reuse.[30] As part of the massive digital effort that led to
the Rijkstudio, the museum also developed and released an API
to their collections information that has scores of developer
subscribers.[31] Peter Gorgels, Digital Manager of the Rijksmu-
seum, commented that openness was merely one part of the
success of Rijksstudio, along with the focused design and the
emphasis on giving users something to do with the art in addi-
tion to looking at it. Taco Dibbits, Director of Collections at
the museum, has said that letting the public take control of
the museum's images has been crucial in encouraging people
to explore the collection more deeply than they might in the
museum's galleries: "The action of actually working with an
image, clipping it out and paying attention to the very small
details makes you remember it." He also made considerable
waves in the cultural sector when he said in response to a ques-
tion asking what if someone did something as inappropriate
as put a Rijksmuseum Vermeer on toilet paper. "If they want
to have a Vermeer on their toilet paper, I'd rather have a very
high-quality image of Vermeer on toilet paper than a very bad
reproduction."[32]

How times have changed!

Promiscuous ≠ easy

Being promiscuous will not be easy for the sector. It will
require approaching our work in new ways, taking on a greater
responsibility, and counting our digital audiences as unique
and different from our physical ones. Resources will need to be

applied and reapplied to deliver these assets to the commons we could become integral to. I think it's worth it. Given finite time and resources, promiscuous sharing is a way of finally delivering on the ambitions of those Enlightenment thinkers who dreamed of universal knowledge diffusion. There's already an audience out there, one potentially numbering in the billions, who might use the content we set free. The technologies exist to make it possible for any museum to stake out a place in the commons. And museums are already beginning to tentatively step out into this new territory.

ACKNOWLEDGEMENTS

This essay originally appeared in the online version of CODE | WORDS in July, 2014. It has been updated by the author to (hopefully) address comments from readers.

It's impossible to name all the people who helped make this essay possible, but the following people I'd like to thank formally:

The CODE | WORDS conspirators, for sharing their ideas and passion with us. Their willingness to experiment is a brilliant example of the kind of professionalism that makes me optimistic about the future of museums.

Koven Smith, for providing crucial commentary and provocation to the assertions I made in the original version of this essay. He embodied the goal of stimulating online discourse that CODE | WORDS aspired to, but largely failed to achieve. Most of the changes in this revised version stem from trying to answer his penetrating questions.

Emily Fry and Trevor Smith, who don't appear by name anywhere in this chapter, but whose creativity and collaborative spirit have shown me so much about what openness looks like in practice.

And last, but not least, Theo Jansen, whose 25 year long experiment/art project has shown me so much about what digital promiscuity really looks like in the wild. Dank je wel!

FIG. 4: *Animaris Umerus*, by Flickr user ume-y [detail].
CC-BY 2.0, found at https://www.flickr.com/photos/ume-y/5435919579/.

NOTES

1. www.youtube.com/results?search_query=strandbeest.

2. otonanokagaku.net/english/magazine/vol30/index.html.

3. www.shapeways.com/shops/theojansen.

4. Theo Jansen, personal communication.

5. Cynthia E. Coburn, Amy K. Catterson, Jenni Higgs, Katie Mertz, and Richard Morel, "Spread and Scale in the Digital Age: A Memo to the John D. and Catherine T. MacArthur Foundation," page 19.

6. Promiscuous – indiscriminate, without discrimination. From the Latin pro – "for" and miscere "to mix".

7. www.ted.com/talks/matt_ridley_when_ideas_have_sex.

8. https://github.com/thewarholmuseum/digital-strategy.

9. In Merete Sanderhoff (ed.) Sharing Is Caring, 2014, page 14.

10. "The wide open future of the art museum: Q&A with William Noel". http://blog.ted.com/2012/05/29/the-wide-open-future-of-the-art-museum-qa-with-william-noel/. Retrieved June 20, 2014.

11. Discriminating – able to note or observe a difference; distinguish accurately: to discriminate between things. From the Latin discernere: dis – "apart" and cernere "to separate".

12. https://medium.com/tedx-experience/dark-matter-a6c7430d84d1. And chapter two of this book.

13. kovenjsmith.com/archives/1446.

14. kovenjsmith.com/archives/1452.

15. Skeu·o·morphic [skyoo-uh-mawrf-ik]: exhibiting ornament or design copied from a form of the object when made from another material or by other techniques.

16. Jon Voss, personal communication.

17. www.theguardian.com/culture/2014/jul/04/museum-year-what-makes-winner.

18. https://medium.com/code-words-technology-and-theory-in-the-museum/changing-museums-f82c98f33f92 and chapter 8 of this book.

19. labs.cooperhewitt.org/2012/releasing-collection-github/.

20. https://medium.com/code-words-technology-and-theory-in-the-museum/
museums-so-what-7b4594e72283.

21. In Merete Sanderhoff (ed.) Sharing Is Caring, 2014, page 40.

22. In Merete Sanderhoff (ed.) Sharing Is Caring, 2014, page 113.

23. msc.mellon.org/research-reports/Open Access Report 04 25 13-Final.pdf/view.

24. www.powerhousemuseum.com/collection/database/download.php.

25. labs.cooperhewitt.org/2012/releasing-collection-github/.

26. www.tate.org.uk/about/our-work/digital/collection-data.

27. research.kraeutli.com/index.php/2013/11/the-tate-collection-on-github/.

28. labs.cooperhewitt.org/2012/exploring-shape-collections-draft/.

29. https://medium.com/code-words-technology-and-theory-in-the-museum/a-place-
for-everything-6bb881c2cbe3.

30. https://www.rijksmuseum.nl/en/rijksstudio.

31. www.museumsandtheweb.com/mw2012/programs/the_rijksmuseum_api.html.

32. www.nytimes.com/2013/05/29/arts/design/museums-mull-public-use-of-online-
art-images.html.

ABOUT THE AUTHORS

ALEIA BROWN is a visiting research and museum practice scholar at the Michigan State University Museum where she works primarily on a collaborative curatorial project with the Desmond and Leah Tutu Legacy Foundation. Her written work, mainly covering museums, race, and gender issues, has appeared in *Slate*. Aleia is currently a doctoral candidate in public history, and holds an MA in Public History from Northern Kentucky University, and a BA in African-American History from Coppin State University's Honors College. She is the co-founder of two Twitter chats, #MuseumsRespond-toFerguson with Adrianne Russell, and #BlkTwitterstorians with With Joshua Crutchfield.

SUSE CAIRNS is the Director, Audience Experience at The Baltimore Museum of Art. An Australian based in the USA, she explored the museum technology sector for many years on her blog *Museum Geek*, and as co-producer and host of *Museopunks*, the podcast for the progressive museum. A prolific writer, and regular presenter at conferences including Museums & the Web (USA), Museums Australia, INTERCOM, Museum Computer Network (MCN), and the National Digital Forum (NZ), Suse has also been published in *Curator The Museum Journal*, on the Museums Association UK website, and other websites and publications. She is currently on the Executive Committee of the MCN Board, and, in 2015, was Program Co-Chair for the annual MCN Conference. She holds a PhD in Creative Arts and a BFA, both from The University of Newcastle as well as a BArts from Charles Sturt University,.

JANET CARDING, a museum professional for almost three decades, began her career with curatorial and then management roles at London's Science Museum, and was one of the leaders of the team that created its Wellcome Wing extension in 2000. In 2004 she moved to Sydney becoming the Assistant Director, Public Programs & Operations at the Australian Museum, the oldest museum in Australia. After six years in Sydney, Janet was appointed Director and CEO of the Royal Ontario Museum, one of Canada's leading museums with encyclopedic collections in natural history and world cultures. In 2015 she returned to Australia to take up her current role as Director of the Tasmanian Museum and Art Gallery in Hobart, a combined museum, art gallery and herbarium which stewards, interprets and contributes to Tasmania's natural and cultural heritage.

KATY PAUL-CHOWDHURY has more than fifteen years' experience working with organizations to achieve focused change, first as a consultant and partner at Schaffer Consulting in Stamford, CT, and then as founder of The Change Agency. She teaches in the MBA program at the Ivey Business School, University of Western Ontario and is based in Toronto, Ontario, where she has recently launched a company providing professional business writing services. She has a long-standing interest in museums, and a particular affection for the Royal Ontario Museum, where she is an enthusiastic member, patron, and volunteer. Katy holds a PhD in strategic management from the University of Western Ontario. www.INKorporatedbusinesswriting.com

MICHAEL PETER EDSON is a strategist and thought leader at the forefront of digital transformation in the cultural sector. He is a Presidential Distinguished Fellow at the Council for Libraries and Information Resources (USA), serves on the OpenGLAM advisory board for Open Knowledge, and he works at the Smithsonian Institution in Washington, DC. Michael is also an O'Reilly Foo Camp alumni and was named a *Tech Titan: Person to Watch* by *Washingtonian* magazine. The opinions in this essay are his own.

BRIDGET MCKENZIE is director of Flow UK, a cultural consultancy based in London, delivering evaluation and audience research for learning and digital programmes in museums and heritage. She founded Flow UK in 2006, subsequently supporting its establishment in India. Previously she has been Head of Learning at the British Library, Education Officer for Tate, lead consultant for Clore Duffield's Artworks Awards and Co-ordinator of Young at Art for the University of the Arts. Bridget is known for furthering the role of "creative enquiry" in education and for placing culture at the heart of a shift to a sustainable future, publishing her thinking on *The Learning Planet* blog and in other publications. In addition, she curates creative community projects on ecological themes, using photography, poetry, songs and visual art. She holds both a BA Hons and MA in History of Art, and two teaching qualifications.

LUIS MARCELO MENDES is a journalist, design and communication consultant, based in Rio de Janeiro, Brazil. He has worked for twenty years with public and private companies specializing in communication, branding, digital media,

publishing, exhibitions and promotional projects, and his work has been selected for and won awards in festivals both in Brazil and abroad. Consultant at the Roberto Marinho Foundation, Luis is currently working on two new museums under construction in Rio de Janeiro: the Museum of Image and Sound and the Museum of Tomorrow.

MIKE MURAWSKI currently serves as the Director of Education & Public Programs for the Portland Art Museum and as Founding Editor of ArtMuseumTeaching.com, a collaborative online forum for reflecting on issues of teaching, learning, and experimental practice in the field of art museum education. He earned his MA and PhD in Education from the American University in Washington, DC, focusing his research on educational theory and interdisciplinary learning in the arts. Prior to his position at the Portland Art Museum, he served as Director of School Services at the Saint Louis Art Museum, and as Head of Education and Public Programs at the Mildred Lane Kemper Art Museum at Washington University. Mike currently serves as the Pacific Region Director for the Museum Division of the National Art Education Association. He is passionate about how we can come to see museums as creative sites for transformative learning, public participation, and community engagement.

NICK POOLE is the Chief Executive of the Chartered Institute of Library and Information Professionals (CILIP), a professional body representing 13,000 information specialists across the UK. Prior to joining CILIP, Nick was Chief Executive of the Collections Trust, the UK-based organisation for collections

management in museums and cultural institutions. Nick is a champion of open knowledge and currently serves on the Board of Wikimedia UK, the UK chapter of the international Wikipedia movement. He has worked with Governments and NGOs to develop programmes for cultural heritage and technology and has brokered partnerships with leading technology companies including Google and the BBC. He has published and lectured worldwide.

ED RODLEY is Associate Director of Integrated Media at the Peabody Essex Museum in Salem, MA, where he manages a wide range of digital media projects. Prior to that he was senior Exhibit Developer at the Museum of Science, Boston. He is a passionate believer in the informal learning that is at the heart of the museum experience and has developed everything from exhibitions to apps. His practice is deeply influenced by constructivist learning theory, but he's no zealot. Ed is enthusiastic about incorporating emerging digital technologies into museum practice and their potential to create a more open, democratic world. His recent publications include *Star Wars: Where Science Meets Imagination* and *Mobile Apps for Museums: The AAM Guide to Planning and Strategy* and he blogs about museum issues at *Thinking about Museums*. He served on the Board of Directors of the Museum Computer Network (MCN) from 2012-2015, and was the Conference Program Co-chair from 2014-2015.

ADRIANNE RUSSELL is a museum evangelist, literary artist and nonprofit consultant. She has written and presented about the intersections of art, race, gender, equity, inclusion and

culture for *Temporary Art Review*, *Smithsonian Magazine*, The Museum Life with Carol Bossert, Museum Computer Network, and her blog, *Cabinet of Curiosities*.

JOHN RUSSICK is the Vice President for Interpretation and Education at the Chicago History Museum (CHM). Since 1998, he has led the development of a host of exhibition, program, and digital experiences for the museum. Prior to that he held positions at Chicago's Field Museum and the National Museum of American History. His recent publications include *Connecting Kids to History with Museum Exhibitions* (Left Coast Press, 2010) and *Remembering Chicago: Crime in the Capone Era* (Turner Publications, 2010). He served as a consultant to the 2011 Florentine Films documentary, *Prohibition*, directed by Ken Burns and Lynn Novick. He organizes the annual Excellence in Exhibition Label Writing Competition for the American Alliance of Museums. He served as Vice Chair of CHM's Visioning Committee, an initiative that culminated with the publication of *Claiming Chicago: Shaping Our Future* (2007), available on the museum's website.

MERETE SANDERHOFF is Curator and Senior Advisor in the field of digital museum practice at Statens Museum for Kunst in Copenhagen, working to provide free access to, and encourage re-use of, the museum's digitised collections. She is a frequent speaker and moderator at international digital heritage conferences. A conference organiser herself, she has set the agenda for openness in the Danish GLAM community at the international Sharing is Caring seminars in Copenhagen. Merete has published substantial research in the area of digital

museum practice, including in the anthology *Sharing is Caring: Openness and Sharing in the Cultural Heritage Sector* (2014). She serves on the Europeana Foundation Management Board, the OpenGLAM Advisory Board, and the ARTstor Museum Advisory Counsel.

ROBERT STEIN is a museum leader, technology expert, and strategist with more than ten years' experience in the museum field heading up innovative projects and diverse teams. During that time, he has pioneered the adoption of open source tools for the museum community, created the world's first incentive-based loyalty program for visitor engagement, and has transformed the discussion about how technology can enhance and drive educational and public impact in museums. Rob is a sought-after author, speaker and consultant, focusing on the impact museums can have in their community, how technology efforts can change the dynamic of museum innovation, and how metrics and measurement can drive continuous improvement in the practice of museums.

ALSO FROM MUSEUMSETC

THE MUSEUMSETC BOOK COLLECTION

10 Must Reads: Inclusion – Empowering New Audiences

10 Must Reads: Interpretation

10 Must Reads: Learning, Engaging, Enriching

10 Must Reads: Strategies – Making Change Happen

A Handbook for Academic Museums, Volume 1: Exhibitions and Education

A Handbook for Academic Museums, Volume 2: Beyond Exhibitions and Education

A Handbook for Academic Museums, Volume 3: Advancing Engagement

Advanced Interpretive Planning

Alive To Change: Successful Museum Retailing

Contemporary Collecting: Theory and Practice

Collecting the Contemporary: A Handbook for Social History Museums

Conversations with Visitors: Social Media and Museums

Creating Bonds: Successful Museum Marketing

Creativity and Technology: Social Media, Mobiles and Museums

Engaging the Visitor: Designing Exhibits That Work

Inspiring Action: Museums and Social Change

Interpreting the Art Museum

Interpretive Master Planning

Interpretive Training Handbook

Museum Retailing: A Handbook of Strategies for Success

Museums and the Disposals Debate

Museums and the Material World: Collecting the Arabian Peninsula

Museums At Play: Games, Interaction and Learning

Narratives of Community: Museums and Ethnicity

New Thinking: Rules for the (R)evolution of Museums

On Food and Health: Confronting the Big Issues

On Sexuality - Collecting Everybody's Experience

On Working with Offenders: Opening Minds, Awakening Emotions

Oral History and Art: Painting

Oral History and Art: Photography

Oral History and Art: Sculpture

Reimagining Museums: Practice in the Arabian Peninsula

Restaurants, Catering and Facility Rentals: Maximizing Earned Income

Rethinking Learning: Museums and Young People

Science Exhibitions: Communication and Evaluation

Science Exhibitions: Curation and Design

Social Design in Museums: The Psychology of Visitor Studies (2 volumes)

Sustainable Museums: Strategies for the 21st Century

The Caring Museum: New Models of Engagement with Ageing

The Exemplary Museum: Art and Academia

The Innovative Museum: It's Up To You...

The Interpretive Trails Book

The New Museum Community: Audiences, Challenges, Benefits

The Power of the Object: Museums and World War II

Wonderful Things: Learning with Museum Objects

VERTICALS | writings on photography

A History and Handbook of Photography

Naturalistic Photography

Poetry in Photography

The Photographic Studios of Europe

Photography and the Artist's Book

Street Life in London

Street Life in London: Context and Commentary

The Photograph and the Album

The Photograph and the Collection

The Reflexive Photographer

COLOPHON

Published by MuseumsEtc Ltd, 2015.
UK: Hudson House, 8 Albany Street, Edinburgh EH1 3QB
USA: 675 Massachusetts Avenue, Suite 11, Cambridge, MA 02139

www.museumsetc.com
twitter: @museumsetc

MuseumsEtc books may be purchased at special quantity discounts for business, academic, or sales promotional use. For information, please email specialsales@museumsetc.com or write to Special Sales Department, MuseumsEtc Ltd, Hudson House, 8 Albany Street, Edinburgh EH1 3QB.

A CIP catalogue record for this book is available on request from the British Library.
ISBN: 978-1-910144-71-8

The paper used in printing this book comes from responsibly managed forests and meets the requirements of the Forest Stewardship Council™ (FSC®) and the Sustainable Forestry Initiative® (SFI®). It is acid free and lignin free and meets all ANSI standards for archival quality paper.

Dolly Pro, the typeface in which the main text of this book is set, is designed by Underware, a specialist type design studio founded in 1999 and based in The Hague, Helsinki and Amsterdam. The font is "a book typeface with flourishes", designed for the comfortable reading of long texts. The asymmetrically rounded serifs give the type a friendly but contemporary look - and it uses old-style numerals, which we love.

Myriad Pro was designed by Robert Slimbach and Carol Twombly for Adobe Systems and is the sans serif typeface probably best known as Apple's corporate font.